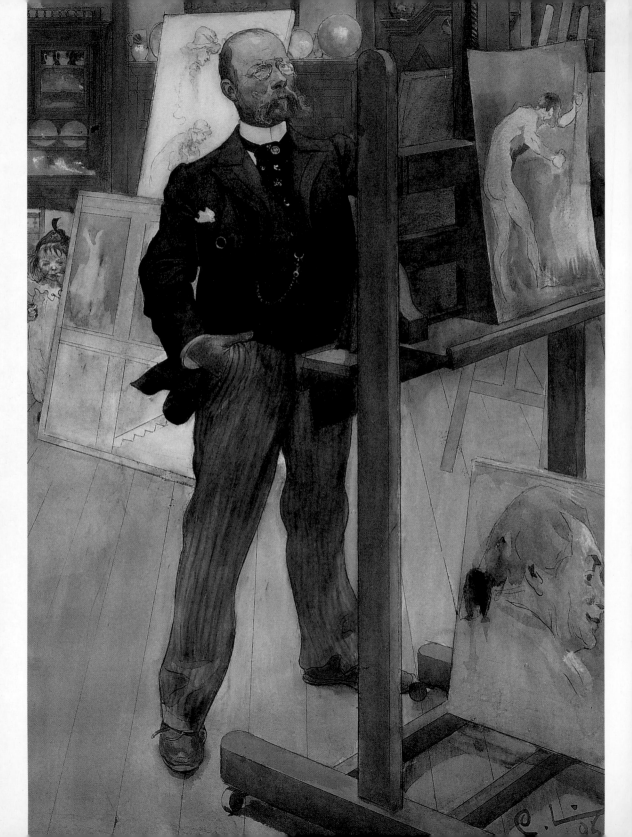

Carl Larsson
Watercolours and Drawings

with a text by
Renate Puvogel

TASCHEN

KÖLN LISBOA LONDON NEW YORK PARIS TOKYO

FRONT COVER:
The Kitchen (detail), 1890–1899
cf. illustration pp. 52/53

ILLUSTRATION PAGE 2:
Self-portrait, 1895
Watercolour, 44 x 32 cm
Stockholm, Prins Eugens Waldemarsudde

BACK COVER:
Breakfast under the Great Birch (detail), 1890–1899
cf. illustration pp. 46/47

**This book was printed on 100% chlorine-free
bleached paper in accordance with the TCF standard.**

© 1994 Benedikt Taschen Verlag GmbH
Hohenzollernring 53, D-50672 Köln
Edited and designed by Angelika Muthesius, Cologne
Text by Renate Puvogel, Aachen
English translation by Michael Claridge, Bamberg

Printed in Portugal
ISBN 3-8228-8572-X
GB

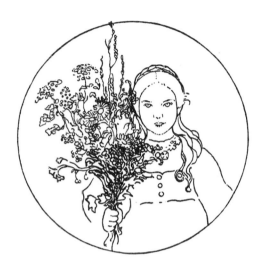

I STAND IN A BEAUTIFUL
BIG MEADOW/WHERE EVERY-
THING IS COLOURFUL WITH
FLOWERS ALL AROUND

Carl Larsson: *A dream of happiness and a good life*

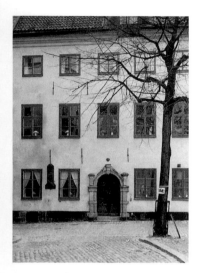

The house in Stockholm where Carl Larsson was born

Carl Larsson himself has provided us with the means, in the form of his artistic work, through which we can trace the close correspondence not only of his unique personality but also of his art to his own life. Anyone familiar with his picture books *Our Home*, *Our Place in the Country* and *My Family* feels himself transported upon reading them to peaceful, almost heavenly surroundings. Yet Larsson is not portraying some dream-like idyll here; rather, his drawings painted in watercolour reproduce a reality that has been experienced by the artist and can thus be regarded as a visual journal. However, the albums only bear witness to the second half of his life, from about 1885 onwards, although they should also be appreciated as a hard-won counter-image to his truly dreadful childhood and youth.

Carl Larsson was born in 1853 in Prästgatan No. 78, a house on the Tyska Stallplan in the Stockholm Old Town of Gamla Stan. His mother was later thrown out of the house, together with Carl and his brother Johan; after enduring a series of temporary dwellings, the family moved into Grev Magnigränd No. 7 (later No. 5) in what was then Ladugardsland, present-day Östermalm. "As a rule, each room was home to three families; penury, filth and vice thrived there, leisurely seethed and smouldered, eaten-away and rotten bodies and souls. Such an environment is the natural breeding ground for cholera," he wrote in his autobiographical novel *Me* (*Jag*, Stockholm, 1931, p. 21). The disease indeed broke out once again in 1866, plunging the poor quarter into even greater misery. As a result of plague and crop failure, more than 100,000 people left their Swedish homeland between 1868 and 1873 to emigrate to America. The fact that the poor quarter was pulled down as early as the 1890s is an indication of just how miserable living conditions in the working-class area were. "It was Hell on Earth! Hunger was the least of our problems – in time, you get accus-

tomed to existing on little… we regularly had nothing… Consumption raged, bloody fights seethed around us, you lived in the midst of prostitution, pointed to murderers and thieves." (*Me*, p. 8) Carl's father was also a good-for-nothing who worked as a casual labourer, sailed as stoker on a ship headed for Scandinavia, and lost the lease to a nearby mill, only to end up there later as a mere grain carrier. Larsson portrays him as a loveless man lacking self-control; he drank, ranted and raved, and incurred the lifelong anger – indeed, the hatred – of his son through his outburst, "I curse the day that you were born." In contrast, Carl's endlessly working mother provided for their everyday needs through her job as a laundress and was ever concerned, despite incessant overexertion, that her children should have the necessary security. Carl will have inherited his artistic talent from his grandfather on his mother's side, a painter by trade, while his grandmother satisfied his childish imagination by telling him wild fairytales. Usually, however, little Carl had to lend a hand himself, fetching water, delivering laundry, chopping wood, and occasionally even conjuring up a meal out of thin air.

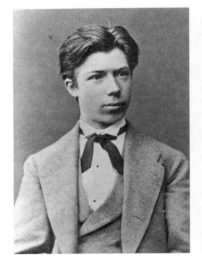

Carl Larsson aged 19, 1872
Photograph: A. Roesler

Larsson describes in *Me* his first artistic attempts, recording how he plundered his father's meagre library in order to cut figures out of the printed pages in the manner of cut-out silhouette portraits. It is possible that this represented a consolidation, even at this early stage, of his great gift in fixing a figure or an object by means of a clear contour.

It is fortunate that Jacobsen, Carl's strict teacher at the Poor School, became aware of his pupil's drawing talent and recommended the thirteen-year-old for the foundation class of the art academy in Stockholm. In contrast to many of the roughly 100 students, who were there merely because they wished to improve their professional training as craftsmen, Larsson was accepted in 1869 for the course on classical art. He struggled reluctantly through the curriculum, which paid homage alone to the classical ideal of beauty, and considered himself fortunate on landing three years later in the course for nude drawing. Of greater importance than nude drawing, however – despite the fact that this actually earned the young pupil his first medal – was his sideline as caricaturist for the humorous paper *Kasper* and thereafter as graphic artist for the newspaper *Ny Illustrerad Tidning*. His annual wages

were even sufficient to allow him to help his parents out financially. His clever, sharply observant sketches, caricatures and drawings reveal that he already possessed a committed – if nonetheless distanced – perception of reality.

Instead of wholeheartedly adopting this form of direct reporting, however, Larsson aspired on completing his studies to the career of an academic painter. Together with his friend Ernst Josephson, the painter and art writer, he left in 1877 for Paris, at that time the melting pot of western art. Yet he was not eager to establish contact with the French artists of progressive Impressionism; indeed, he by and large cut himself off, along with other Swedish artists, from the radical movements of change. After spending two summers in Barbizon, the refuge of the plein-air painters, he settled down in 1882 with his Swedish painter colleagues in the little town of Grez, 70 kilometres away from Paris. Here his fate began to undergo a radical change. Larsson discovered for himself the watercolour technique, and this process of applying colour in a gently glazing, atmospheric manner would remain this artist's fundamental discovery for his future artistic activity. While he would occasionally continue to make use of opaque oil paints, working in watercolours was to become his essential métier. It was in this medium that he would execute his narrative albums; those portraits done in the watercolour technique demonstrate a particular expressiveness; and even his monumental wall-frescoes exude the aura of a delicate sensitivity to colour, "the impression of a splendid sketch" (*Me*, p. 194) – a quality, however, which those commissioning works from him would criticize as "lacking in monumentality" and being "similar to illustrations".

Living in the humid, warm climate of the pastoral idyll at Grez, he recorded details from a precisely observed environment in hazy, bright shades. Unlike oil painting, the watercolour technique lends itself particularly to an accentuation rich in colour values of the entirety of a picture dissolved into atmosphere through individual details such as flowers, bushes and courtyards. In contrast to the French plein-air painters, however, the Swedish artist was interested not only in setting free what was painted through his direct experience of nature but also in celebrating mankind, both in harmony with nature and as its culmination. He has captured individuals in momentary situations, such as a gentleman fishing,

Carl Larsson in 1882, shortly after becoming engaged

clad in the historical fashion of the 18th century (*Taking the Bait*, 1885), or a peasant woman in a pumpkin field (*October*, 1882). The result is a gently poetic realistic lyricism of nature.

The following events from this period may be regarded as of particular moment. In 1879, he met his future wife, the Swedish artist Karin Bergöö, and shortly prior to this Pontus Fürstenberg, a patron thirty years older than himself and a merchant in Gothenburg. The early 1880s were a period for the artist of considerable journeying between France and Sweden, of intensive creativity, and – as a co-founder of the artistic association of Swedish "Opponents" – also of activity in the sphere of art politics. Larsson's prestige was growing; after several unsuccessful attempts, his pictures were finally accepted by the Paris Salon in 1883 and even given an award. Thanks to his narrative talents, he was much in demand as a book illustrator. Among other works, he provided the illustrations to Andersen's fairytales, Schiller's *Cabal and Love*, and the novel *Singoalla* by his friend the poet Viktor Rydberg; in 1881, August Strindberg asked him to work on the writer's *The Swedish People on Workdays and Public Holidays*. A decades-long friendship would bind the two artists from 1879 onwards, until Strindberg publicly attacked the painter in 1908.

Larsson was sounding out the broad spectrum of graphic techniques, from drawings in pencil, charcoal and pen, via etchings, woodcuts and xylographs, to watercolours. His works fuse historicizing quotations with excursions into Symbolism, together with Japanisms pointing forward to Art Nouveau, while all-too-sentimental or academic passages are refreshingly interspersed with caricatural moments, sometimes in the spirit of Daumier, sometimes in the manner of Wilhelm Busch or Zille.

As well as such commissions for book illustrations, the artist was already receiving requests for wall paintings. A trip to Italy, during which he studied the frescoes of the Italian Early Renaissance in Venice and Rome, encouraged him to try his hand at the monumental format. Directly after he had been invited in 1888 by his patron, Pontus Fürstenberg, to draw up a triptych for the latter's residence, Larsson applied for the commission to decorate the stairwell of the National Museum in Stockholm with frescoes. This work would drag on over a period of some decades with several invitations for new and revised bids, and Larsson would

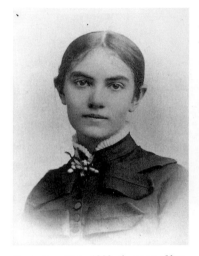

Karin Bergöö in 1882, the year of her engagement to Carl Larsson

never get over the rejection of his final design, *Winter Solstice Sacrifice*, its candid portrayal of the King being regarded as intolerable. The three frescoes, the art forms of which were linked to historical subjects, were nonetheless executed, as were other representations from Swedish history. These were followed by other works commissioned by the Norra Latin School in Stockholm, by a grammar school for girls in Gothenburg, and for the foyer of the Stockholm Opera.

Larsson's reputation was growing. However, he owed the fact that he was also recovering emotionally to Karin Bergöö, whom he married in 1883. She was not only a loyal wife, the centre of the constantly growing family, a good mother to his seven children, the soul of the household, but also his veritable life-spring, his muse, the critical companion of his work. He recorded her tender face with its frame of dark hair, in numerous watercolours; she, for her part, was also creatively occupied, decisively involved in the renovation and expansion of a new centre for their life, namely their house in Sundborn.

In 1888, the young Larsson family received the little house of "Lilla Hyttnäs" in Sundborn, near Falun, north of Stockholm, as a present from Karin's father. During the 1890s, the family would use the little timber house directly by the bend of the Sundborn stream merely as a summer residence; in 1901, however, they finally moved into their country home. From this point on, we can leave the story of the painter entirely to his own portrayals, for the illustrations will reveal that he has left us in his watercolour albums a precise idea of the house and its continual extension, the individual members of the family, customary events, and the Sundborn farmers and craftsmen taking part in fashioning house and home. These albums form the foundation stone of Larsson's popularity in his home country, and have also established an unforgettable memorial to him far beyond the borders of Sweden. *Our Home* (*Ett Hem*), on which he had been working since 1890, was published in 1899, and *Spadarfvet, Our Place in the Country* (*Spadarfvet, mitt lilla landtbruk*) was to follow in 1906. Although the albums are by no means directed solely at children, Astrid Lindgren has learnt not a little from Larsson.

Whereas his important Scandinavian painting colleagues, such as Anders Zorn or Edvard Munch, charged both the peacefulness

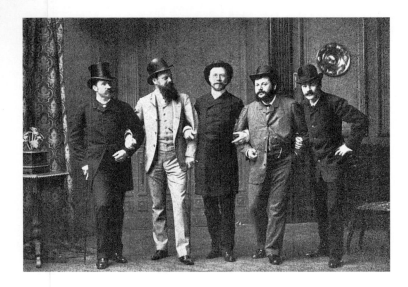

The "Opponents". Carl Larsson is in the middle.
Photograph: Nationalmusei Bildarkiv, Stockholm

and the drama of the Nordic landscape with the human subjects of love and death, tragic fate and middle-class revolution, Larsson was drawing his pictorial journals exclusively from his immediate surroundings. He succeeded in so idealizing everyday adventures and experiences as to create a poetic world. He was compensating through the pictures, for which he himself wrote lengthy texts, for a childhood laden down with cares. A deep religious faith and increasingly conservative views protected the artist from having to call into question, in the face of threatening world catastrophes, his trust in the security of the environment which he had created. His life's work is given exemplary significance by his fine sense of humour, breaking now and then into subliminal irony, by the deeply felt and often expressed gratitude with which he enjoyed his second, real life until his death in 1919, and also by the special style of drawing with which he executed his series of pictures with their texts.

Since the 1890s, when Larsson had found his linear stale, he had renounced a manner of painting comprising a blurred colouring lacking contours and interspersed merely with flashing accents. His colouration continued to be bright and full of variation, but he integrated the wealth of pictorial detail in a clear black contour. This method facilitated the reproduction of his watercolour designs through the printing process, repressing the

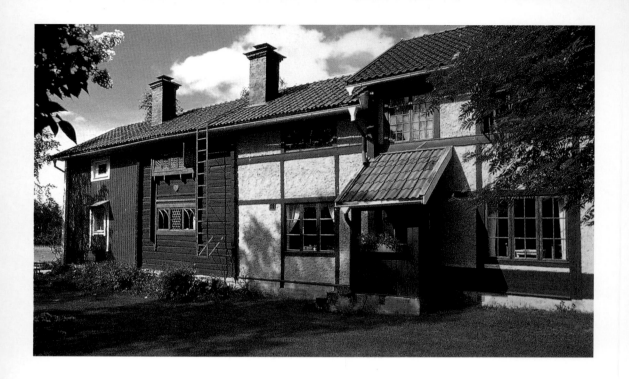

The house of the Larsson family,
"Lilla Hyttnäs", in Sundborn

painter's gesture in favour of a method of distanced, ornamental stylization.

Like numerous artists at the turn of the century, Larsson too incorporated the conciseness, the emphasis on a partial view, and the flatness of Japanese wood-cuts, together with the delicacy of East Asian pen-and-ink drawing into his illustrations. They embed his personal style of drawing in the larger context of the distinguished delicacy and pleasure in the ornamentation of Art Nouveau. The house as backdrop, framing cheerful portraits of children or small anecdotal incidents – no work is without a protagonist smuggled in – rises up before the observer in an originality that is impressively varied in shape and form.

The intention was not only that the albums be seen as picture books but also, over and above this, that they "reform taste and family life". With their suggestions regarding clothing, nutrition, design, furniture, and architecture, the Larssons were anticipating the idea of an integral lifestyle concept, such as would soon be pursued by the likes of the Bauhaus. Sundborn is still regarded

today as pointing the way towards new, sound interior design. As a result of the extension and stage-by-stage enlargement of the house, the estate constitutes a harmonious collage of details borrowed from various styles and motifs together with inventions originating with the house's owners themselves. It is not by chance that comparisons are drawn from today's point of view with Postmodernism on the basis of the jaunty carefreeness with which traditional features are brought into harmony with modern elements.

The favoured material is wood, making its appearance already in the varied structure of the external façades. It is found throughout the imaginatively laid out house, sometimes given a clear stain, sometimes painted white or some other colour. Wooden ceilings and floors radiate a feeling of homely warmth, while the wooden jambs and lintels around the doors and windows structure the surfaces of the walls and emphasize the practical simplicity. People in Sweden around the turn of the century were remembering the Gustavian Rococo style from the 18th century, with deepset white window recesses and graceful furniture bringing brightness and an atmosphere of lightness into the interior. In general, however, historical features mingle with modern design; they give each room its specific character, according to the use to which it was put by the family. The living room exudes the bright atmosphere of white wooden furniture, blue-and-white striped carpets and upholstery covers imitating Gustavian furniture and colours,

whereas the library exudes the impression of a subdued, respectable English style of furnishing. The potentially negative effect of complicated staircases, passageways and dead corners from the old structure is lessened by interior windows, allowing one to look from one room into the next. Built-in seats, cupboards and beds are to be appreciated as the Larssons' own achievements; in contrast, transom windows and glass roundels show the owners also adopting the traditional style of furnishing. It was essential to utilize every available corner if sufficient space was to be offered each member of the family so as to enable him- or herself to fully develop. The joiner thus constructed simple shelves for the extensive library and wall brackets for pottery jugs, while a door to the dining room was made that would hold a folding table. In addition, the painter left no wall or door surface undecorated with some ornamentation or other, the likeness of one of the house's occupants, a plaque, or some pious saying; even window panes were given the same treatment.

The lovingly fashioned home acquired a special flair through the many textiles designed and produced by Karin. The colours and patterns of the rugs, tablecloths, bedspreads, curtains and articles of clothing reveal a sure stylistic feeling and wealth of ideas, should be seen as pointing the way ahead, and contribute to the fluid nature of the boundary between the free and the applied arts. Larsson's albums bear impressive witness to this integral nature.

In 1897, Larsson also purchased the farm of Spadarfvet, together with its outbuildings and an enormous property comprising arable land and pasturage and including woodland and fishing stretches; the extended Sundborn family now also counted craftsmen and farmers among its number. The Larssons lived in a self-sufficient manner, and the children too were taught how to perform every kind of manual and farming job. A washhouse, a larder, a stall and a garage were fitted out, while a studio, originally free-standing, was later joined to the old house by a connecting wing. In his albums, the painter accompanied the family through the year, recording not only the day-to-day tasks and pleasures but also unusual events such as name days and Christmas celebrations. The pictures were complemented by his eloquent texts, directed at the reader and influenced as much by anecdotal elements as by a declaration of belief in the Church and national traditions and cus-

toms, together with his loyalty to the farming class and his move from the liberals to the right wing, which would ultimately end in disillusionment with politics. The artist was unable to completely escape from publicity; it was not only the people of Sundborn, and time and again himself, whom he captured in expressive portraits, for well-off friends also commissioned portraits from the painter. Despite his complaint that "Painting portraits is the very worst thing that I know, and I have always felt as if I were on the way to the execution block" (*Me*, p. 123), he generally gave in to the insistent urging of those wanting a work from him, enabling us to gain precise knowledge of his patrons, his friends, and those interested in him from around the turn of the century onwards.

Larsson's final years were overshadowed by the unresolved disputes concerning the repeatedly revised design for the fresco of the *Winter Solstice Sacrifice* in the National Museum. In his autobiographical work *Me*, Larsson gave voice to his annoyance and rendered account for his life with all its bright and dark sides; he managed to complete it a mere two days before his death on 22nd January, 1919.

Renate Puvogel

KARIN.

KARIN-SAGEN
1 8 9 6

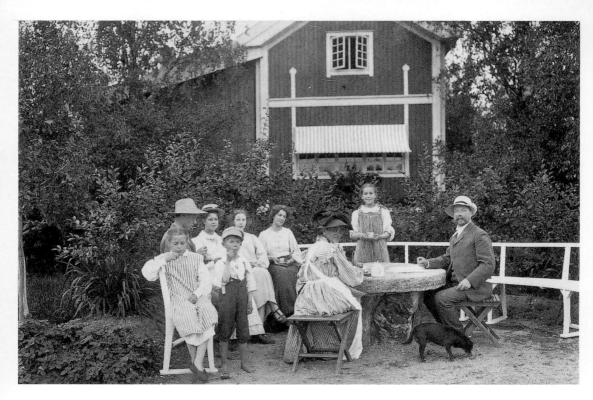

The Larsson family enjoying after-
noon coffee in front of their house,
"Lilla Hyttnäs", in Sundborn,
1906/1907.
Photograph: Carl Larssongården,
Sundborn

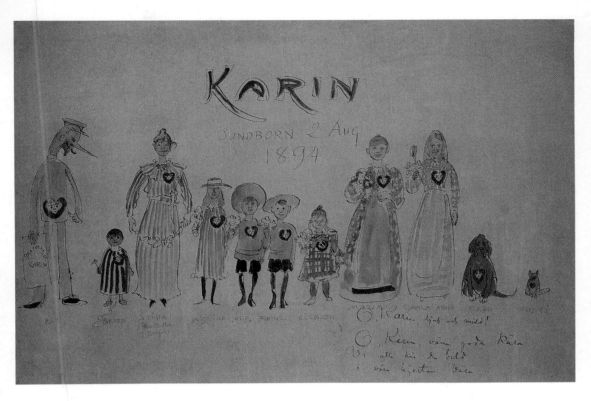

*Congratulations on Karin's Name
Day,* 1894,
Göteborgs Konstmuseum
"O Karin, bright and gentle!/ O
Karin, my dear, good friend/ We all
carry here/ Your picture/ In our little
hearts."

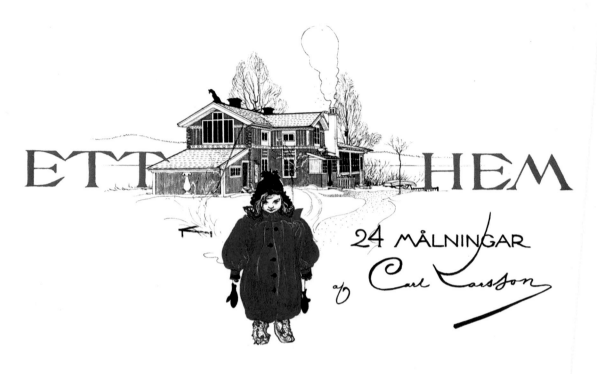

ETT HEM

24 MÅLNINGAR
af Carl Larsson

STOCKHOLM
ALBERT BONNIERS FÖRLAG

"Ett Hem" – Our Home
Cover of the album bearing the same
name, published in Stockholm in
1899. The book contains 24 watercol-
ours, each one c. 32 x 43 cm. Carl Lars-
son began the work in 1890; it did not
come out until almost ten years later.

Illustration page 19: *"Larssons"*
Cover of the album bearing the same
name, published in Stockholm in
1902. The book includes 32 watercol-
ours, each one c. 33 x 49 cm. Along with
the *Ett Hem* and *Spadarfvet* albums (see
pp. 80/81), it contains the most beautiful
pictures, portraying the painter's idyllic
home and beloved family.

Larssons.

ETT ALBVM BESTÅENDE AF
32 MÅLNINGAR
MED TEXT OCH TECKNINGAR
allt AF CARL LARSSON själf

STOCKHOLM. ALBERT BONNIERS FÖRLAG.

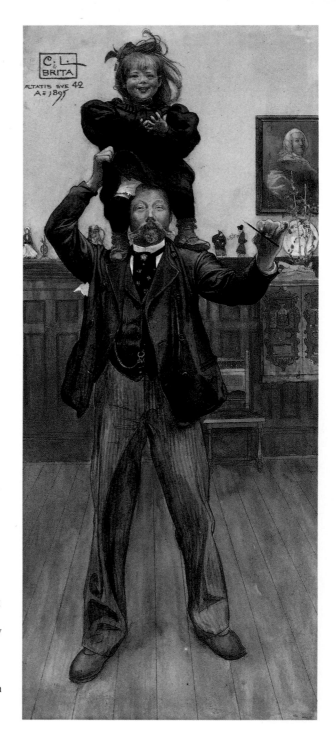

Brita and Me!, 1895,
Göteborgs Konstmuseum
The fifth child is two years old here,
her name included in her father's ini-
tials. Happily triumphant, the two of
them are posing in a domestic ambi-
ence in front of a Baroque painting.
The artist has portrayed himself as a
"spiritus rector", wielding a paint-
brush as if it were a conductor's
baton. Portraits of his children and
himself were to take up an increasing
amount of space in Larsson's work.
"Imagine what it's like trying to draw
the lines with a steady hand and eye,
using ink and pen, while all the time
this little wildcat is yowling, pulling
my hair (oh yes!), and letting fly with
her feet." (*The House in the Sun*,
p. 28)

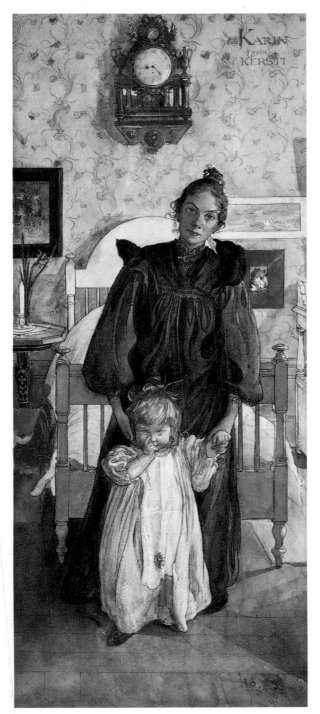

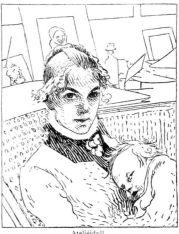

Ateljéidyll.

Karin and Kersti, 1898,
Göteborgs Konstmuseum
Karin with two-year-old Kersti, the
Larssons' sixth child. The loving ges-
tures of the tender, elegantly dressed
mother and the bedroom's masterly
mixture of styles convey a sense of
harmony and inner security.

Suzanne, 1894,
Göteborgs Konstmuseum
The firstborn child, aged ten, standing
on a stool in a corner of the studio in
front of wall-painting designs and Re-
naissance grotesques. Pontus Fürsten-
berg, who had commissioned this pic-
ture, accoladed it and the adjacent
portrait of Lisbeth with an admiring
"Bravo, bravo, bravissimo", and re-
quested the double portrait of the
brothers on the facing page.

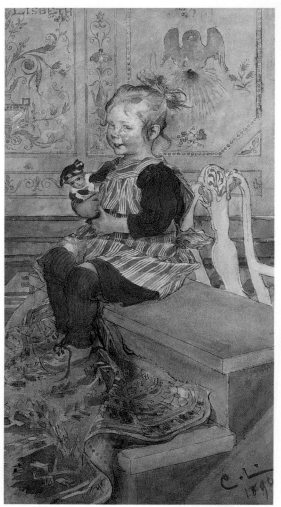

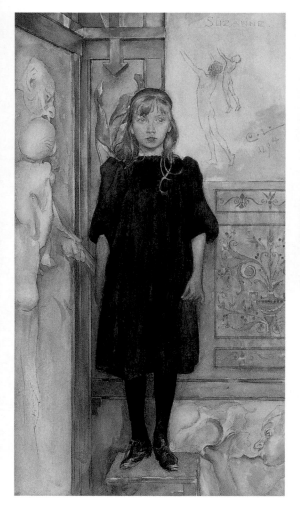

Lisbeth, 1894,
Göteborgs Konstmuseum
The children generally took to their
heels when they were called to model
for their father. Here, Larsson has
been able to confine Lisbeth, born in
1891 as their fourth child, in his stu-
dio, and has characterized the three-
year-old with an almost photographic
snap-shot effect as a mischievous
vagabond.

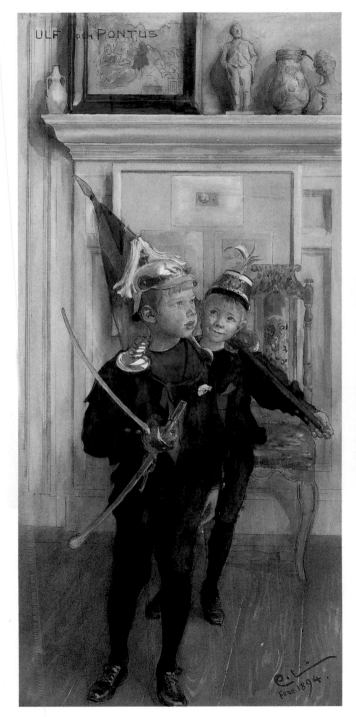

Ulf and Pontus, 1894,
Göteborgs Konstmuseum
Ulf, born in 1887 as their second
child, died in 1905. Here he is play-
ing at soldiers with his younger
brother (born in 1888). Despite the
boys' marching behind each other, the
sense of their playing together is
nonetheless conveyed by means of
lines of vision and diagonals in front
of an appealing art collage.

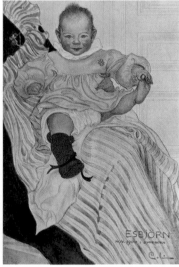

Esbjörn, 1900,
Göteborgs Konstmuseum
As indicated by the title, which Lars-
son often inserted as a sign, Esbjörn,
born in 1900 as their seventh child,
constitutes the subject of the picture.
The painter also takes this idea into
account in the boldly intersected
figure of the child's mother.

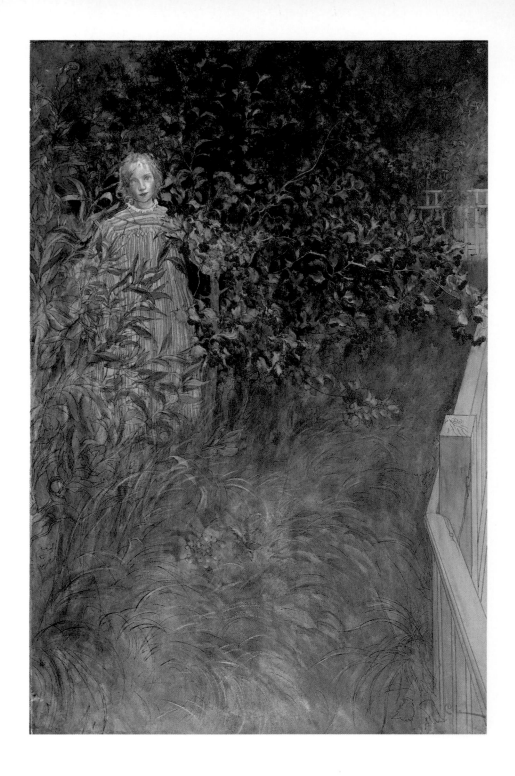

Illustration page 24:
In the Hawthorn Hedge, undated,
private collection
The red accent in the midst of the lux-
uriant green is typical of Larsson's art.

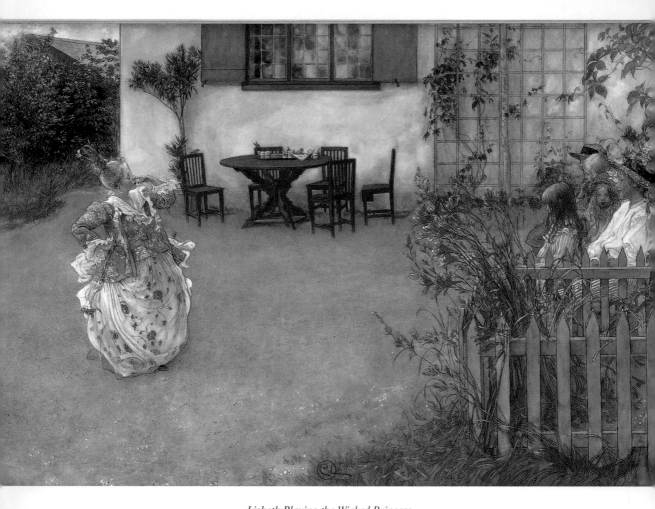

Lisbeth Playing the Wicked Princess in Atterbom's "Fågel Blå" (Blue Bird), 1900, Copenhagen, Statens Museum for Kunst

Emptiness on the one side, fullness on the other, presented in the garden against the backdrop of the house. Here the proud little princess in Rococo costume, standing out against the monochrome sandy ground, there the visibly amused spectators, sitting closely packed together.

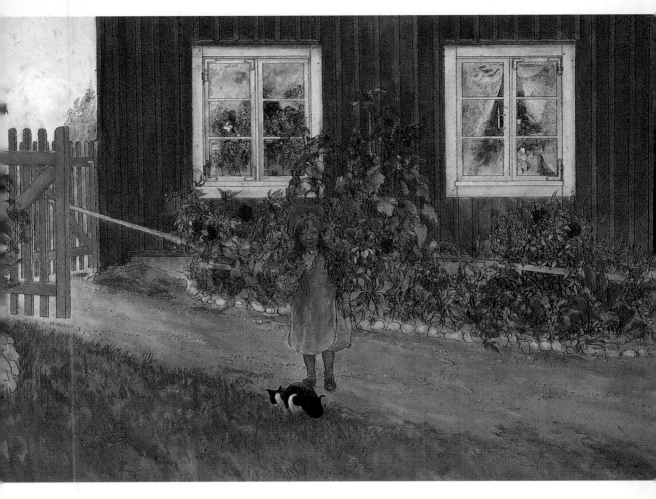

Brita, a Cat and a Sandwich, 1898,
Tällberg, Börjesonska Konst-
samlingen, Green Hotel
Brita as a seven-year-old, eating
her sandwich standing at the open
garden gate, with the lurking cat –
the moment as expression of eternal
happiness.

Illustration page 29:
Raking, c. 1894
"Surely I could have found a better
name for this picture in the end. Any-
way, it's Brita who was given the job
of raking the yard every Saturday
afternoon, naturally against remunera-
tion in hard cash. I like the sight of
the corner behind her, for it no longer
exists as portrayed here; a larder has
been built in there in the meantime."
(*The House in the Sun,* p.29)

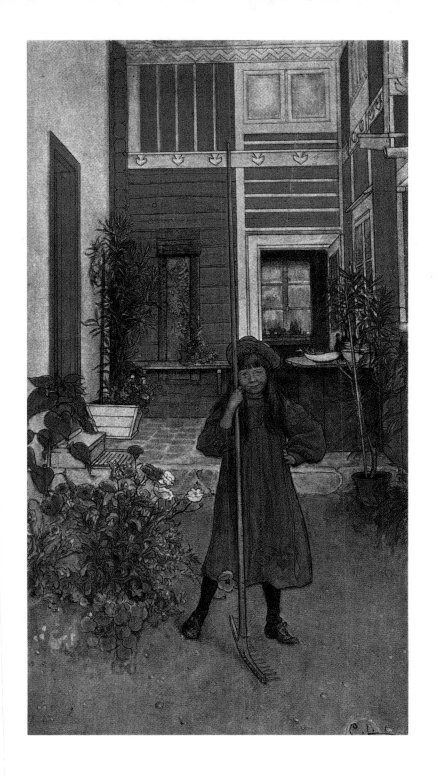

Illustration page 31:
Eighteen Years Old!, 1902
The entrance verandah's wooden sup-
ports in relief and the tendrils sur-
round Suzanne, causing her to blos-
som as a dreamy Art Nouveau figure.

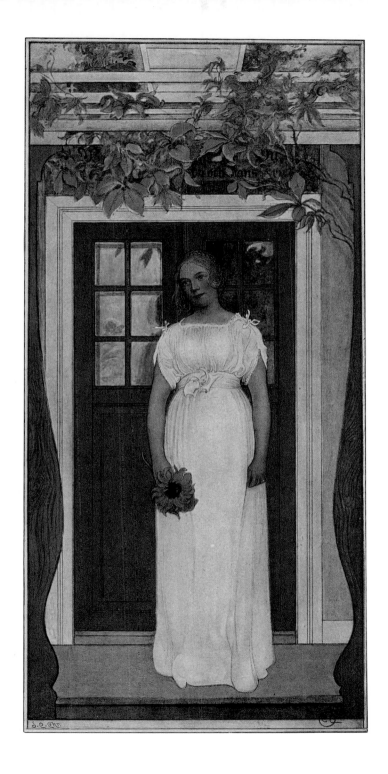

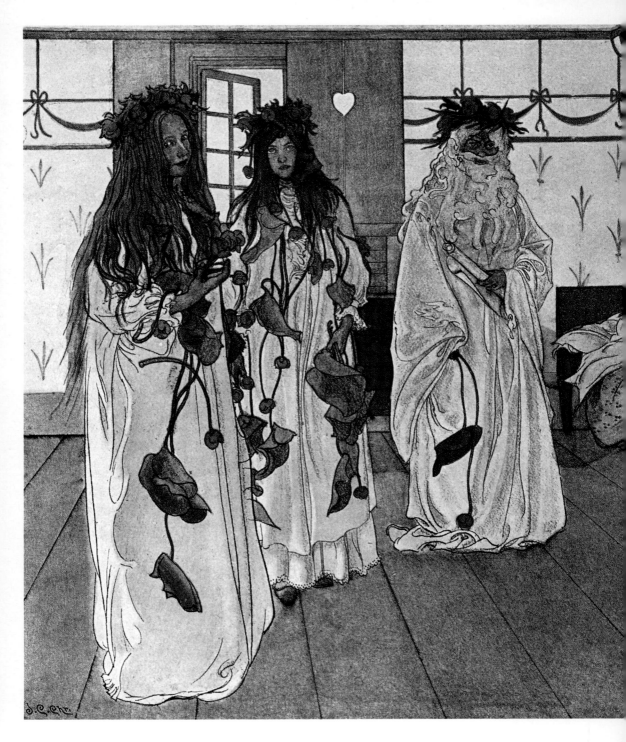

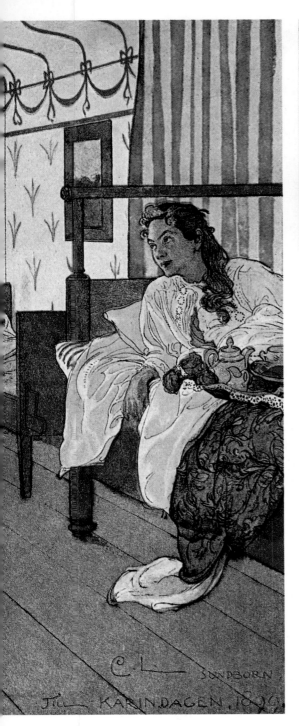

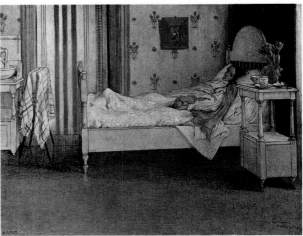

Recovery, 1899
"She is saved! – 'She is out of danger!' the doctor says, and I find him marvellous and awesome; I would clasp his knees if I could give in to my feelings. But what I kiss are her – my poor, beloved, little, thin wife's – slender fingertips, the tips of her sleeves, the plait braided by the nurse, which stands out so black against the white bed. With what enchanting splendour life radiates again!" (*The House in the Sun*, p. 29)

Congratulations on Karin's Name Day, 1899
The cohesion of the family was furthered in particular by the fact that each special occasion was always celebrated anew and with enthusiasm by everyone. This depiction combines actual events and artistic happening. In 1899, the mother's name day could be celebrated cheerfully and with gratitude following her recovery from a potentially fatal illness.

Illustration page 35: *Apple Blossom,*
1894, private collection
The watercolour's date of origin sug-
gests that it is Lisbeth whom the
father has caught here, clasping the
young tree with hands and feet while
coquettishly gathering up her dress.
"My very finest instinct gives me an
idea of how the metrical feet would
dance around the little apple tree in
time with Lisbeth's little legs and all
the others." (*The House in the Sun,*
p. 27)

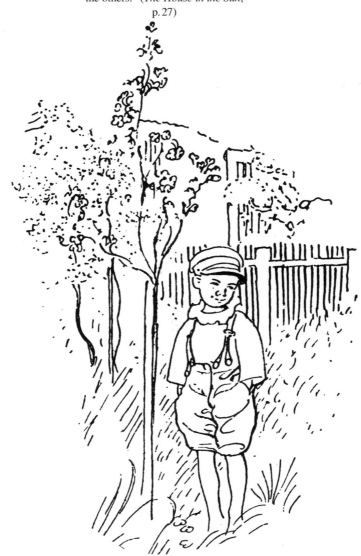

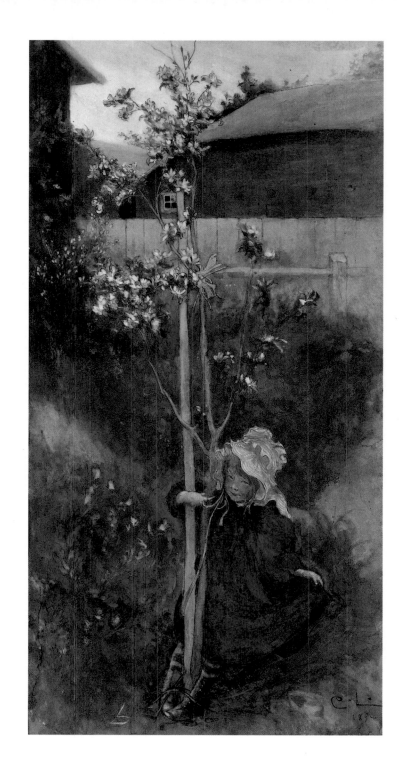

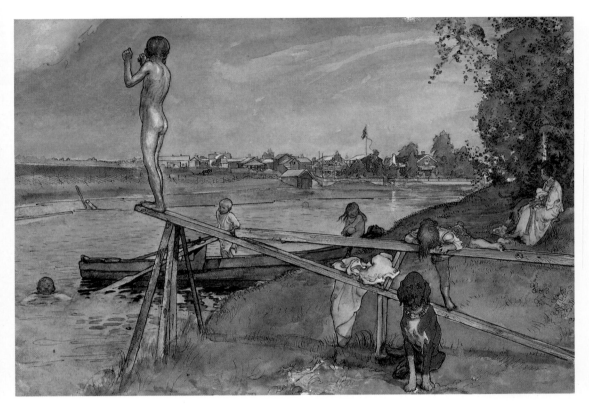

A Good Place to Bathe, between
1890 and 1899,
Stockholm, Nationalmuseum
Further downstream, Larsson pur-
chased the "Lärmeiland" with its bath-
ing area; in summer, the inhabitants
of the entire neighbourhood would
enjoy themselves there around home-
made springboards.

Outing, 1901
Larsson's plein-air painting was
intimate and realistic, much lighter
than that of the Barbizon painters,
who influenced him.

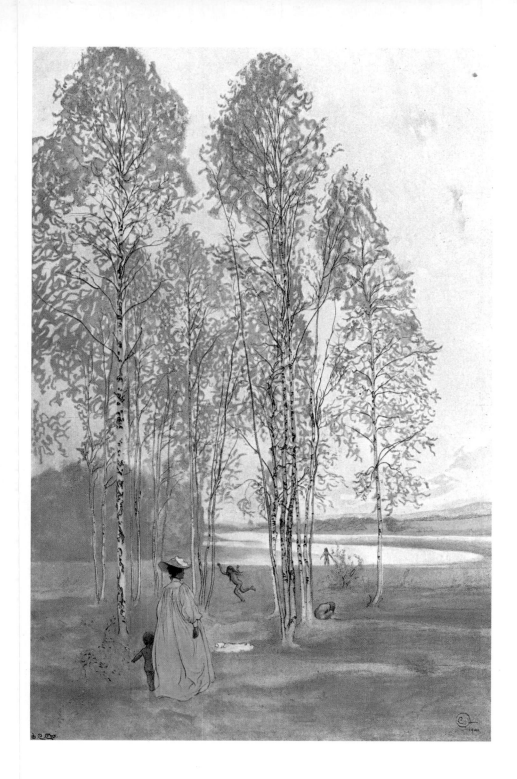

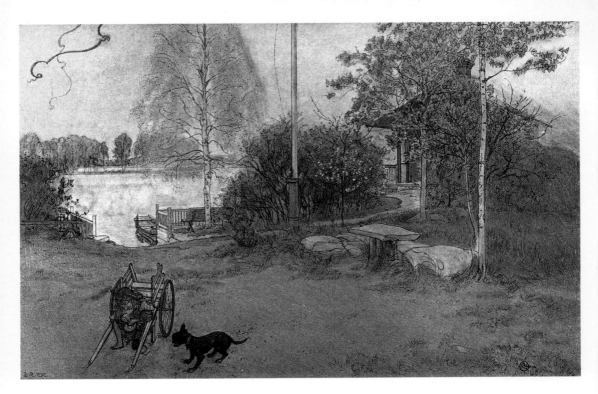

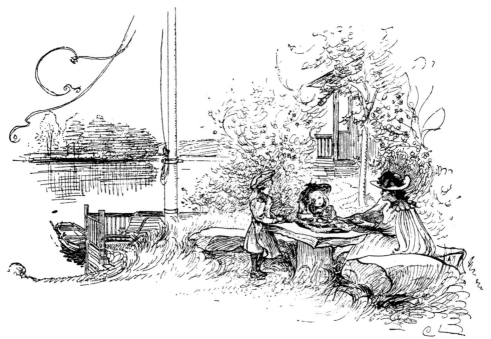

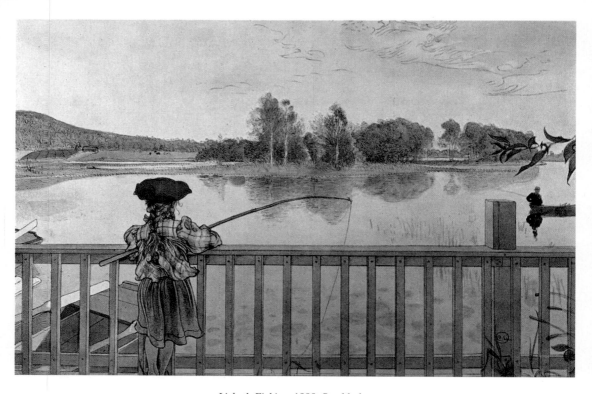

Lisbeth Fishing, 1900, Stockholm,
Nationalmuseum
The property borders directly on the
Sundborn stream. Larsson had a
fence erected along the bank, for the
safety of the children. The trick of
portraying Lisbeth as a repoussoir
figure enables the observer's gaze to
pass from the island in the stream
over to the other bank.

Illustrations page 38:
A comparison of the two drawings
reveals how true to nature the artist's
reproduction of reality is: a corner in
the garden down at the landing-stage
with bench and table, constructed out
of the "sacred stones of the stove" fol-
lowing the latter's renovation.

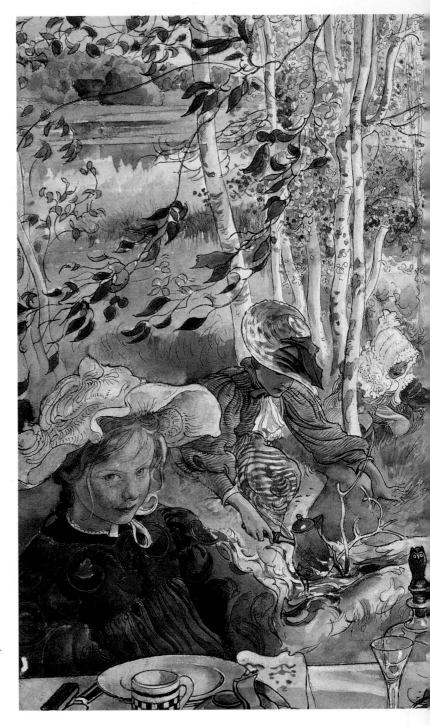

Catching Crayfish (The Start of the Crayfish Season), between 1890 and 1899,
Stockholm, Nationalmuseum
"The crayfish season begins on 15th August" (*Our Home*, p. 44). The fresh catch may be seen on the table, which is boldly intersected by the bottom edge of the picture. The action-packed watercolour exudes the eventful spontaneity of a photograph. Larsson reworked the watercolour as a carton for a tapestry woven in 1900 by the "Friends of Handicraft" and in safe keeping today in the Kunstindustrimuseum Copenhagen.

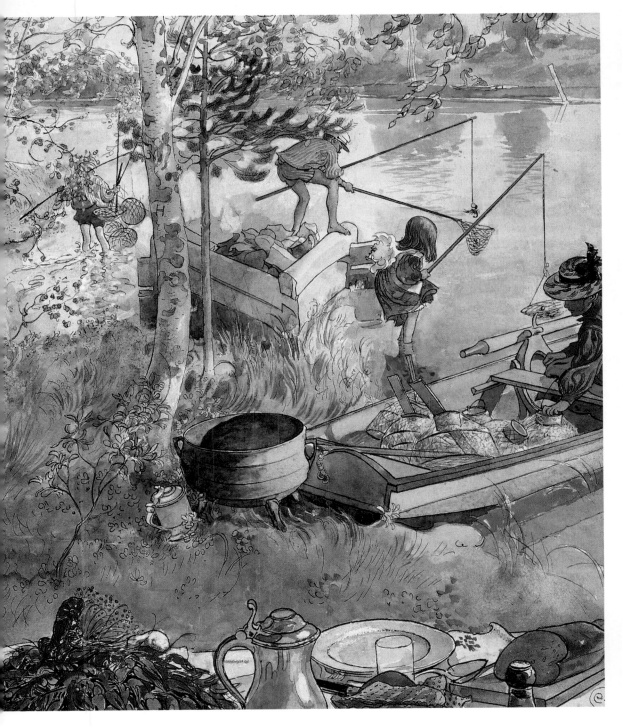

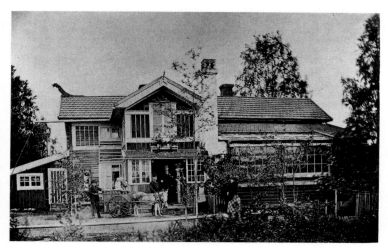

Lilla Hyttnäs in the first half of the 1890s. Photograph: Carl Larsson-gården, Sundborn

The Hut in Snow, 1909,
Abo, Konstmuseum
The view to the northwest towards the entrance, with the former studio, renamed the "workshop", on the right and the new studio projecting on the left; initially freestanding, it was linked to the residential building by a connecting structure.

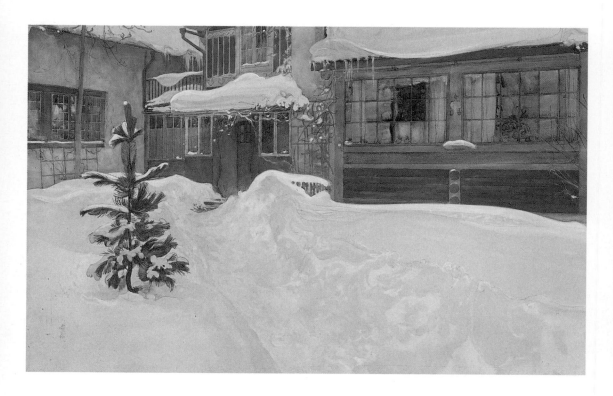

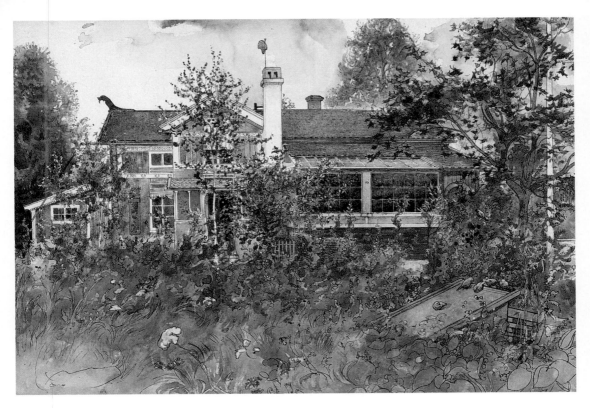

The Hut, between 1890 and 1899,
Stockholm, Nationalmuseum
"Thus appeared the shed in its rural
simplicity" (*Our Home*). The en-
trance façade of "Lilla Hyttnäs", the
original building in the form in which
the Larssons had inherited it in 1888
from Karin's parents.

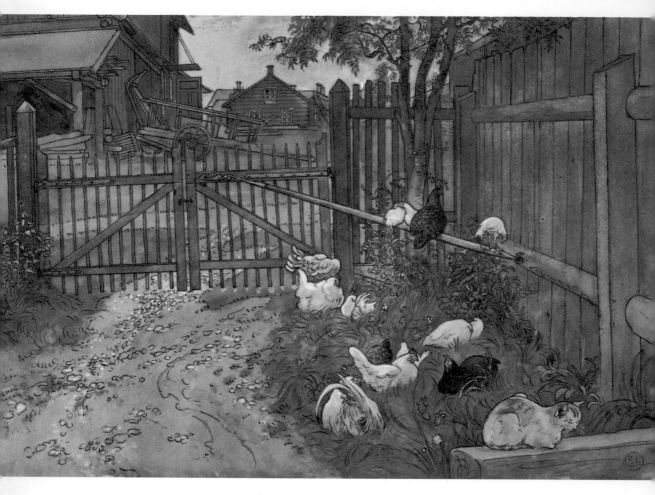

The Gate, between 1890 and 1899,
Stockholm, Nationalmuseum
"The cart jolts in between old junk
and steaming heaps of manure, over
our neighbour's yard and through the
little green garden gate, startling the
half-unconscious hens from their mid-
day sleep." (*Our Home*, p.6)

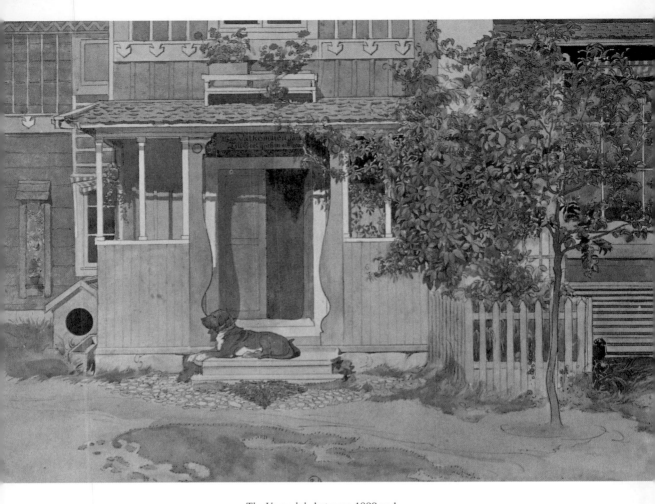

The Verandah, between 1890 and
1899, Stockholm, Nationalmuseum
Larsson's gift in focussing upon spe-
cific details renders the entrance ver-
andah, watched over by Kapo, as an
architectural collage; above the door,
we may read a Swedish adage which
translates approximately as follows:
"Welcome here, whoe'er you be, at
the house of Carl Larsson and his
Lady!"

Breakfast under the Great Birch,
between 1890 and 1899,
Stockholm, Nationalmuseum
"…If this tree hadn't been there, then
the whole estate would have had abso-
lutely no significance for me. It
throws such a wonderful shadow, and
it's just a little bit draughty at that
very spot, just enough to make it un-
pleasant there for midges and moths"
(*Our Home*). All the more pleasant,
therefore, for the people and Kapo,
the dog!

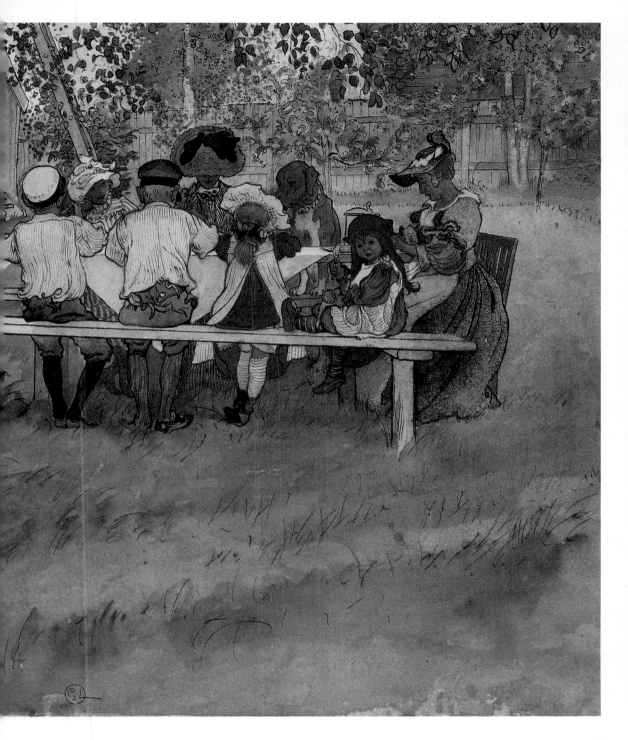

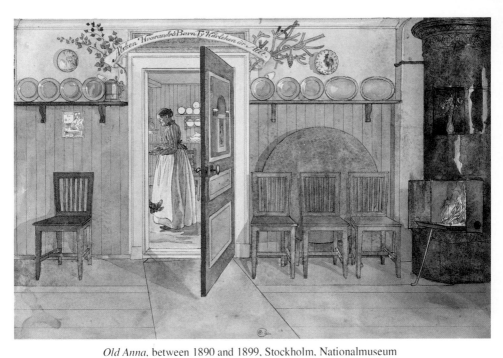

Old Anna, between 1890 and 1899, Stockholm, Nationalmuseum

When the Children Have Gone to Bed, between 1890 and 1899, Stockholm, Nationalmuseum

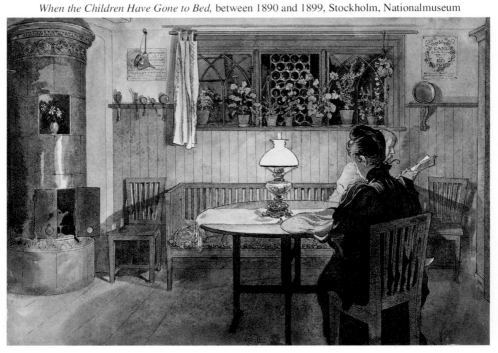

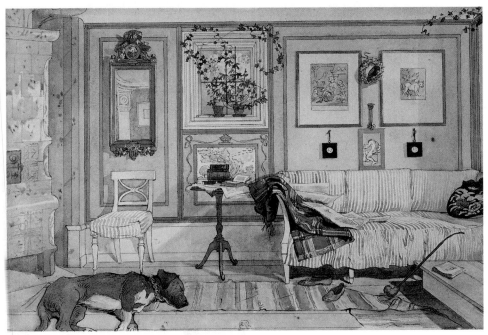

The Resting Place in the Parlour, between 1890 and 1899, Stockholm, Nationalmuseum

The Punishment Corner, between 1890 and 1899, Stockholm, Nationalmuseum

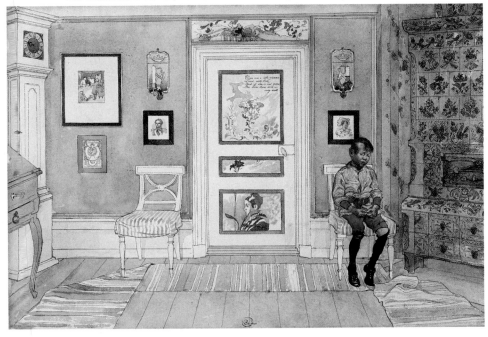

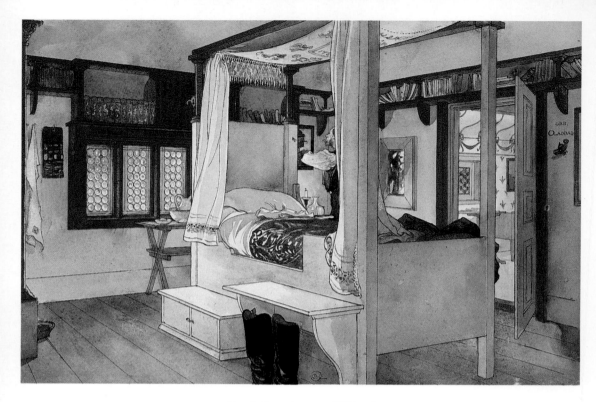

Papa's Room, between 1890 and
1899, Stockholm, Nationalmuseum
A harmonious interior with a free-
standing four-poster bed, textiles de-
signed by Karin, glass roundels to
provide subdued light, and a sparse-
ness of toilet articles. The occupant of
the room is peeping out from behind
the bed's curtain.

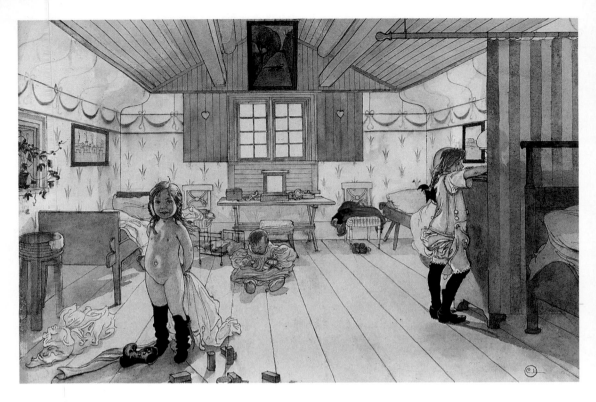

The Bedroom of Mama and the Little Girls, between 1890 and 1899, Stockholm, Nationalmuseum
The girls, affectionately called "cherubs", playing an undressing game in their favourite room in the house. Karin's bed is still separated from those of the children by a curtain here; a bunk would later take its place. After 1900, a clothes room was installed here. The children's beds, painted green and constructed of roof shingles, were designed by Karin; Art Nouveau tendrils lead above them up to the slope of the roof.

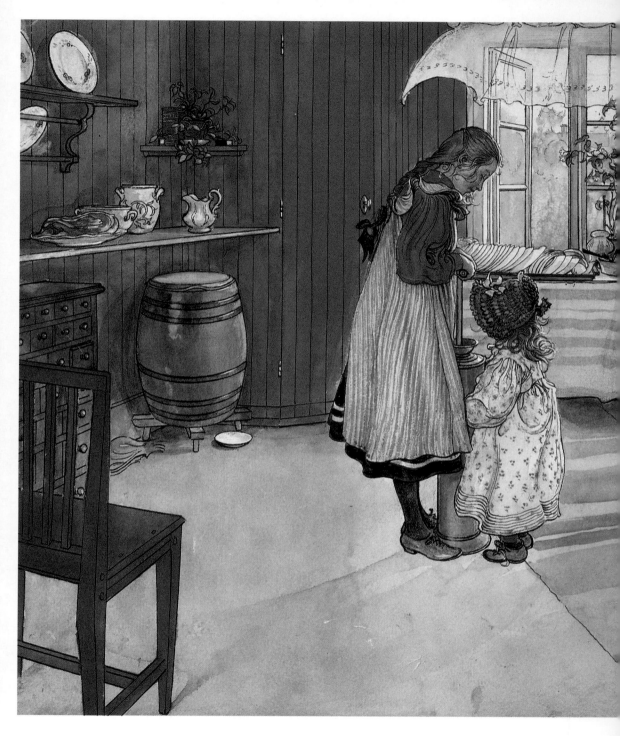

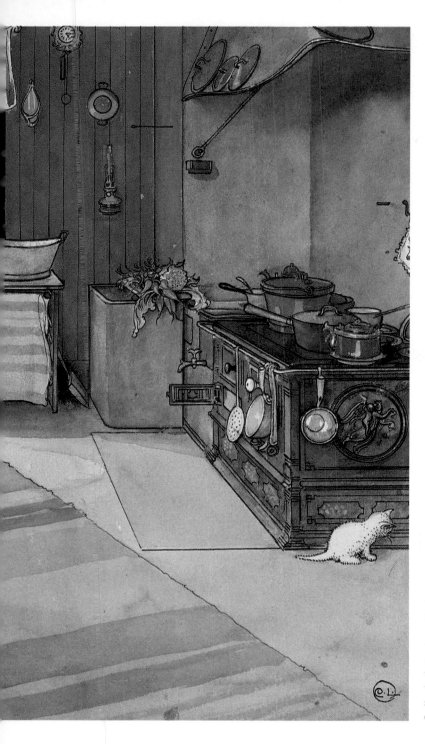

The Kitchen, between 1890 and 1899,
Stockholm, Nationalmuseum
Suzanne and Kersti making butter in
the spacious kitchen with its richly or-
namented cast-iron stove, that "laugh-
able, wretched iron box... decorated
with ornaments, abysmal, insensitive
scrolls, and (– what a beautiful
thought, where did you get it, you
who are Bolinder's Mechanical Work-
shop? –) Thorwaldsen's 'Night'!"
(*Our Home,* p. 36)

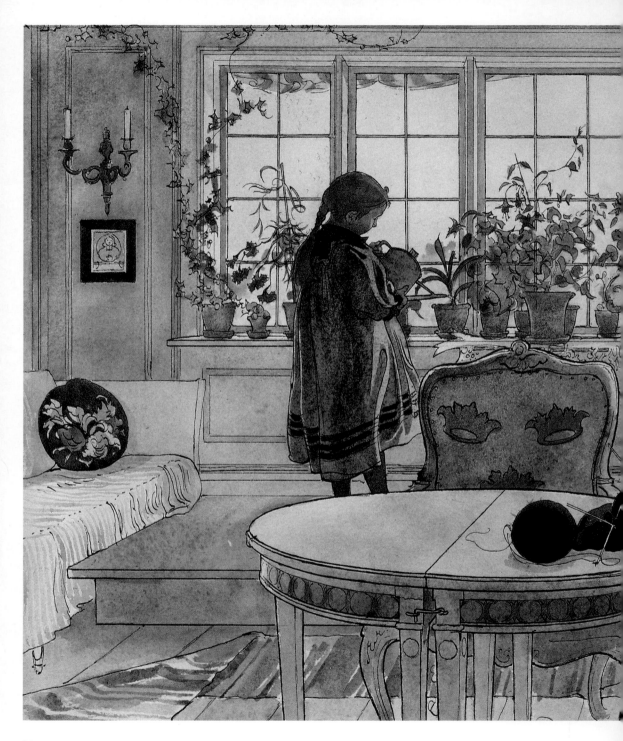

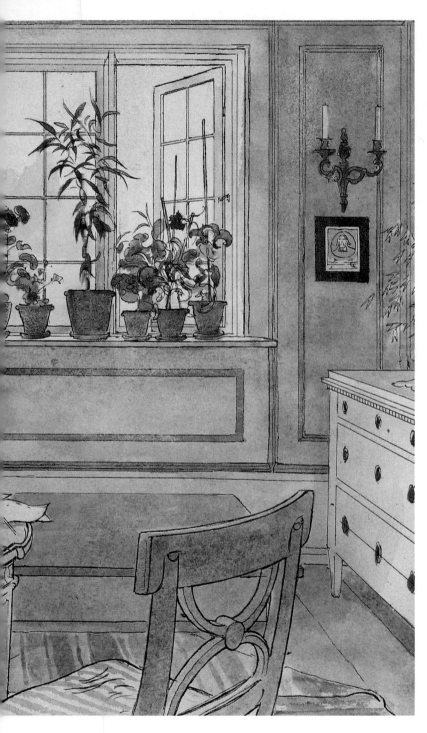

The Flower Window, between 1890 and 1899,
Stockholm, Nationalmuseum
The wide transom window lets ample light into the living room from the side facing the river. Despite its being furnished in an elegant fashion, the room was used for a multitude of purposes by all the members of the family – including the dog. Here we see Suzanne "In the drawing-room with her beloved flowers".
(*Our Home*, p. 28)

Illustration page 57:
Hide-and-Seek, c. 1900
Father's studio was the ideal place for
children's games.

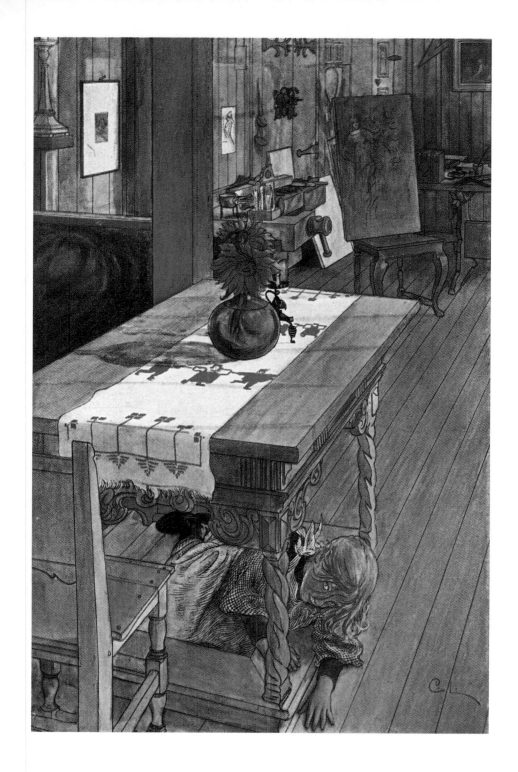

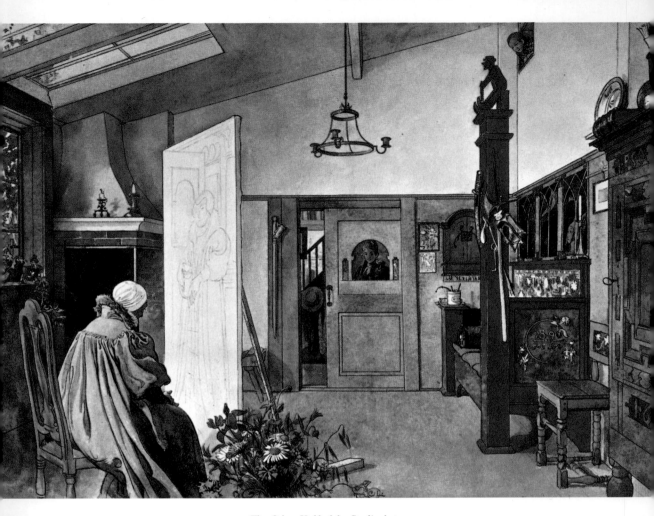

The Other Half of the Studio, between
1890 and 1899, Stockholm, National-
museum
The northeastern corner of the studio,
looking towards the narrow lobby
with coat hooks fixed to the banisters.
The sofa pillar cut here served as a
paint cupboard.

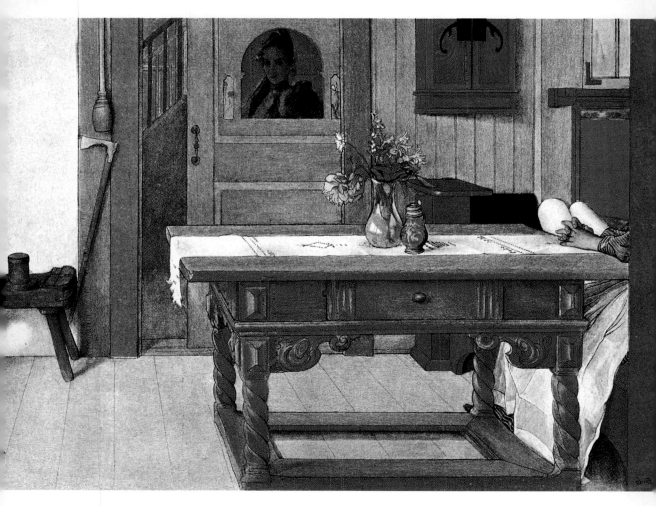

Sunday Nap, 1900,
Stockholm, Nationalmuseum
The same corner of the studio with
the corner seat. Karin, only her hands
visible in the ingenious composition,
develops into a full figure through the
portrait of her painted on the sliding
door to the living room.

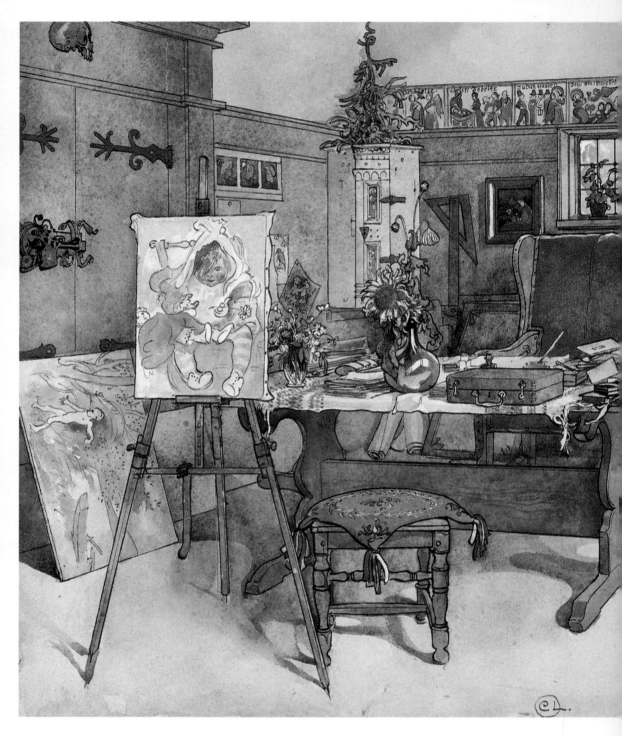

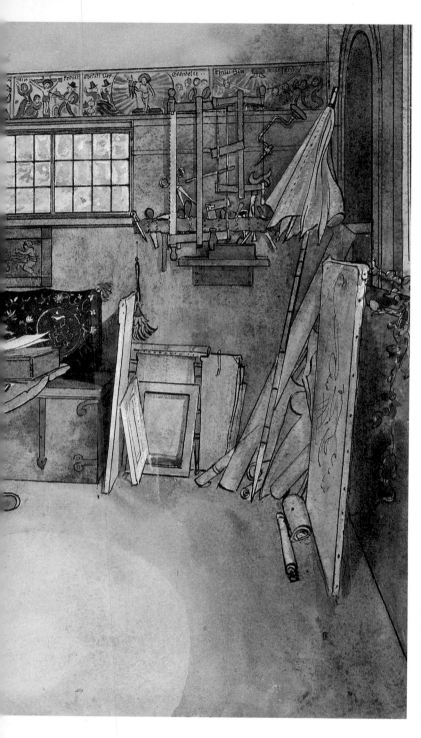

One Half of the Studio, between 1890 and 1899,
Stockholm, Nationalmuseum
The studio, with a heavy old easy-chair and a table. The frieze over the glass roundels and the wall panels contain depictions from the life of Christ; like others, Larsson regarded these folk-art paintings from the 19th-century province of Halland as exemplary.

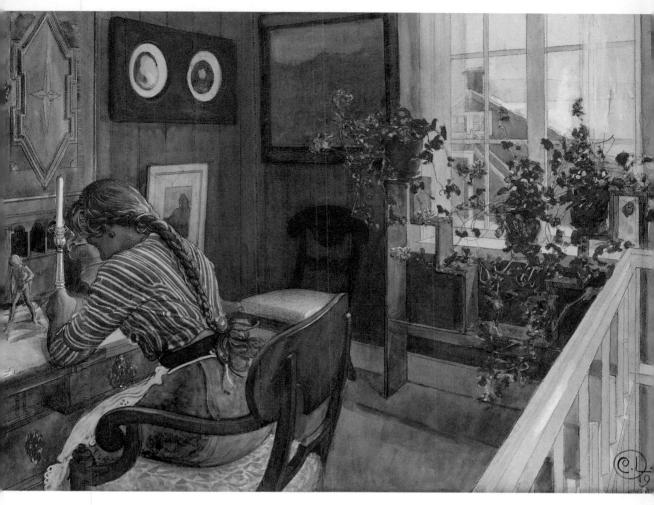

Letter-writing, 1912,
Stockholm, Nationalmuseum
A comparison of this work with other
watercolours strengthens the suspi-
cion that it is the eldest daughter, Su-
zanne, who is engrossed in her work
here at her desk on the top floor. The
stylish and cosy ambience enhances
the status of this through room to that
of a living room. The modern flower
stand, designed by Karin, has become
famous.

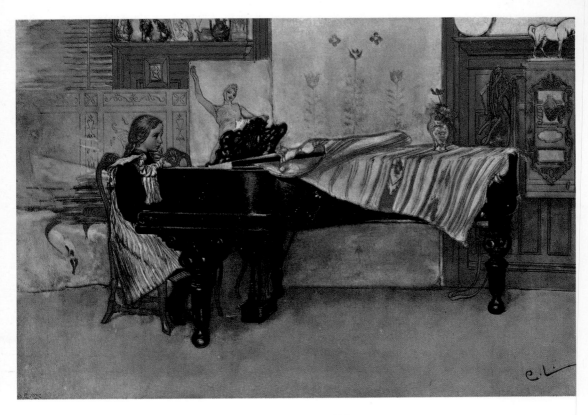

Playing Scales, c. 1898
Great attention was paid to the artistic
education of the children. Karin de-
signed and wove the cover on the
grand piano.

Homework, 1898,
Göteborgs Konstmuseum
The children occupied with their
homework in the dining room. An
example of Larsson's ability to con-
centrate a work on one section.

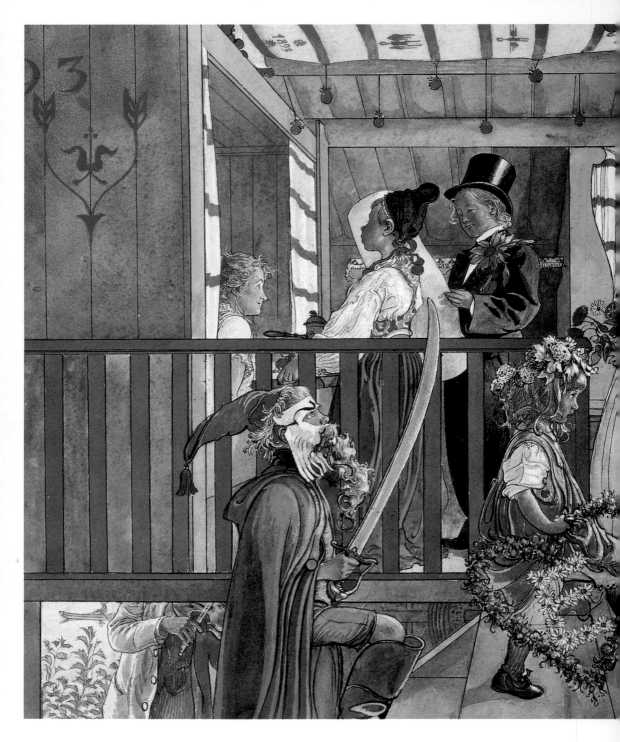

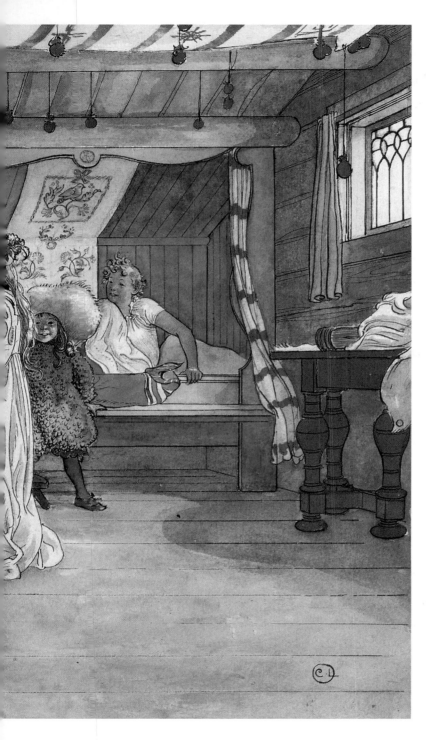

Name Day in the Little Store Room,
between 1890 and 1899,
Stockholm, Nationalmuseum
"It happened once by chance that they
(the big children) were spending the
night in the little store room when
Emma's name day was celebrated by
the children, with fancy dress, coffee
in bed, and a birthday poem delivered
by Suzanne, dressed in my tail coat.
Ulf, disguised as a Dalarna woman,
carried the coffee tray... Johan stood
on the steps, playing his violin, while
the tears were running down dear
Emma's cheeks." (*Our Home*, p. 42)

Illustration page 69:
The Breakfast of the Sleepy-head,
1897
"But how tear-stained and ugly her face looks, my sweet little Kersti!…that's simply because she… is in what to her sensitive self-respect is the awkward situation of having to put together her meal from the remains on the breakfast table and then eat it all by herself." (*The House in the Sun*, p. 28)

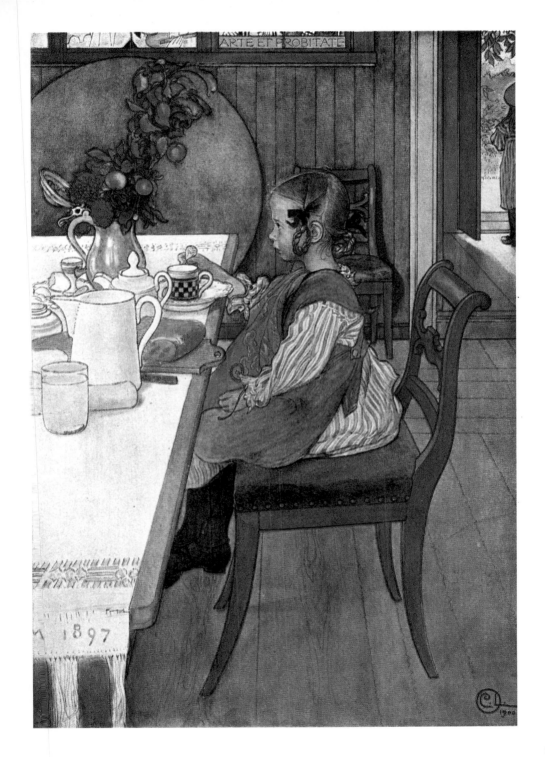

The Chess Game, 1902
Larsson's portraits of children are dis-
tinguished by the fact that the little
ones have been painted in their own
surroundings, as here at the chess-
board.

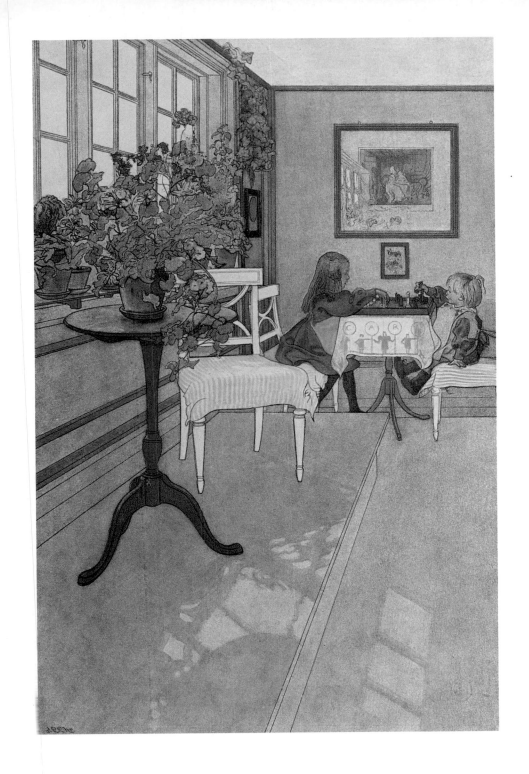

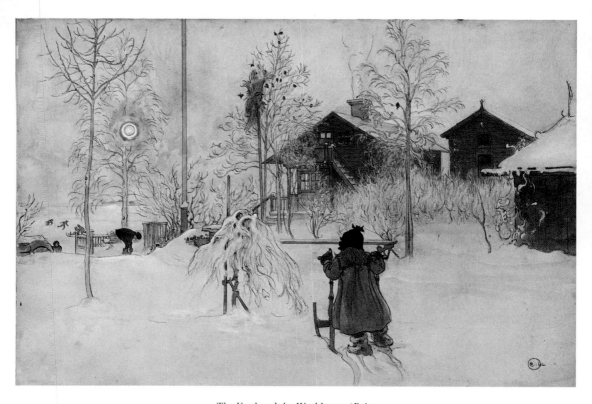

The Yard and the Washhouse (Brita with the Sleigh), between 1890 and 1899, Stockholm, Nationalmuseum
As the years went by, Larsson purchased not only some working quarters but also studios in Stockholm and in the country. Here, the children are looking for a way to amuse themselves during the long Swedish winter. Landscape and event constitute a unity here.

Illustration page 75:
The Day before Christmas Eve, 1892,
Carl Larssongården, Sundborn
In this work, the children stand out
three-dimensionally against the
flat surface of the picture, as in a
trompe l'œil work. Although
merely sketched in, the door to the
Christmas room becomes the surface
of the picture through its decoratively
framing lintel and jambs and the
weathering effect. It is no longer
possible to distinguish what is real
and what has been painted from
each other.

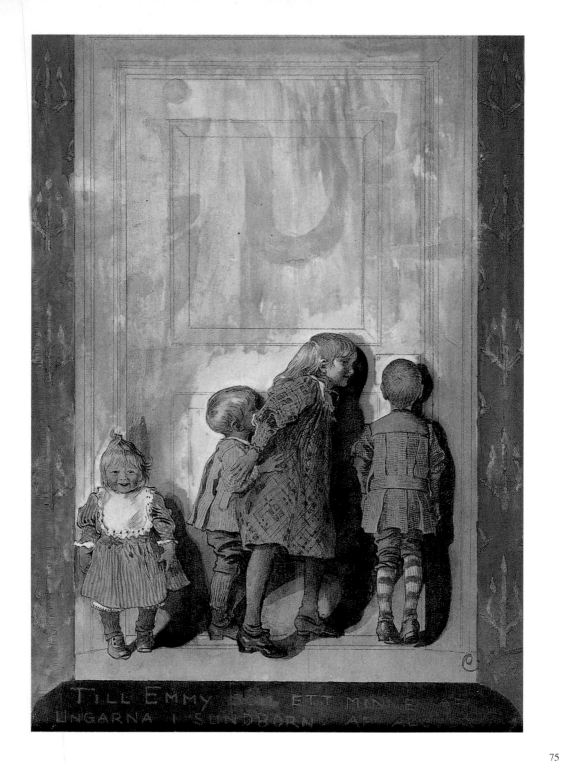

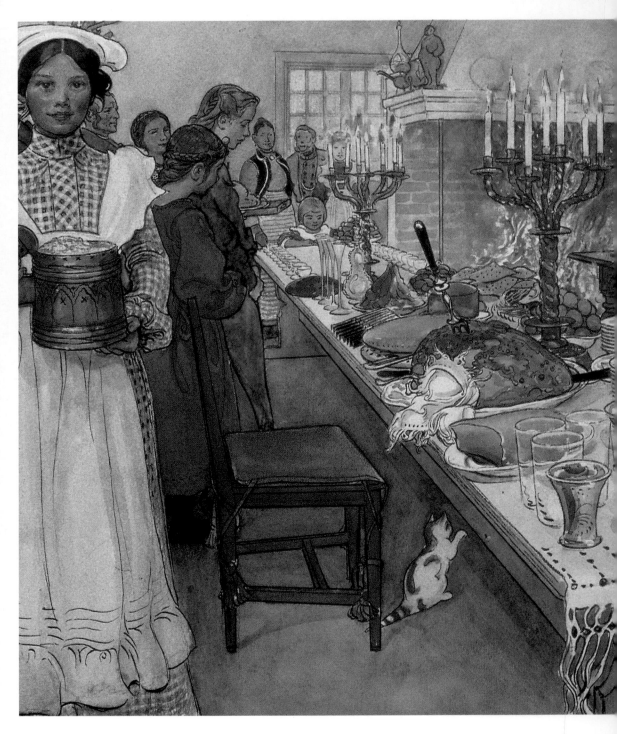

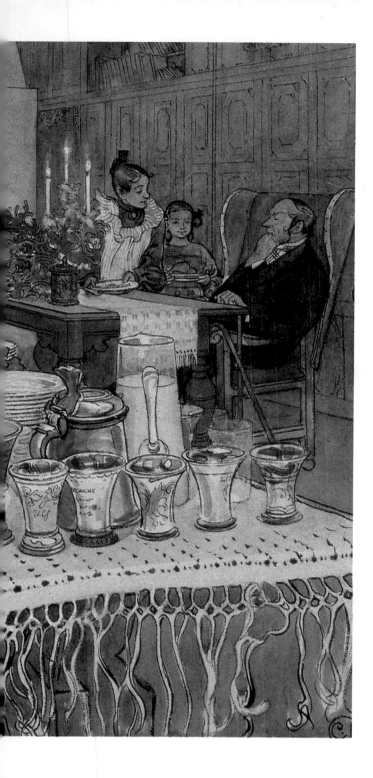

Christmas Eve, c. 1904–06,
Stockholm, Bonnierska Porträttsam-
lingen, Nedre Manilla
The fireplace, a cross between Eng-
lish and Swedish stylistic elements,
and also the turned table and easy-
chair help us to recognize that the
sumptuous Christmas repast – "vir-
tually an agricultural exhibition" – is
being celebrated in the workshop, the
first studio. The Christmas festival
constituted the centre of the year, and
was celebrated by all the occupants of
the estate together. A comparison
with other pictures enables us to iden-
tify Martina, the maid, on the left
here – proof of the extent to which
the physiognomies of familiar figures
find their way into Larsson's pictures.

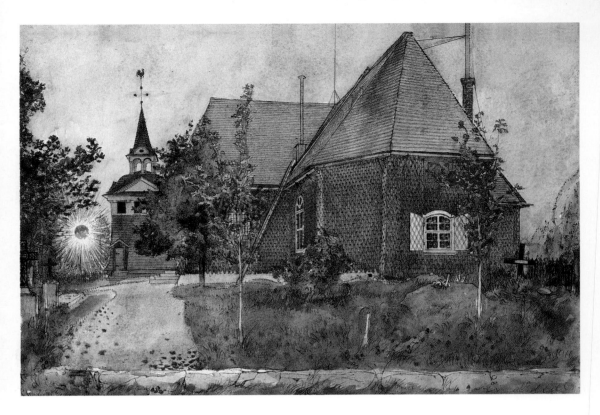

The Old Church in Sundborn,
c. 1904–06, Stockholm, National-
museum
The inhabitants of Sundborn had been
permitted to have their own congrega-
tion since the time of Queen Kristina
(1st half, 17th century); it is probable
that the church was built at this time.
This watercolour constitutes the rich
conclusion to the *Ett Hem* watercol-
our album.

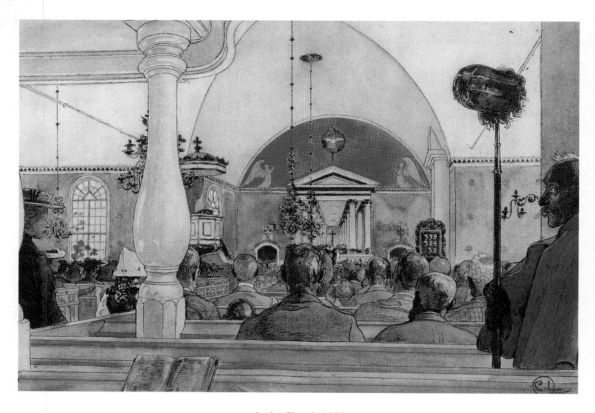

In the Church, 1905
The Sunday service in the Sundborn
church after its renovation. By
presenting us with the amusing rear
view of the congregation, the
religious painter enables our gaze to
pass over the freshly gleaming brass
chandeliers to the spiritual focal
point, the altar area. This watercolour
is one of the pictures in the *Spadarf-
vet* album, published in Stockholm in
1906.

Spadarfvet, Our Place in the Country – The cover of the album by the same name. The book contains 24 watercolours and a cover picture, each work measuring 33 x 49 cm. The majority are signed by Larsson, and some are dated 1904–06.
Stockholm, Bonnierska Porträttsamlingen, Nedre Manilla.
In 1897, Larsson purchased the farm of Spadarfvet, which bordered on Lilla Hyttnäs, thereafter referring to himself as an "artist and farmer". In thus paying homage to the Swedish farmers, the artist was also declaring his political support for the farming culture as the stable basis of the Swedish nation. The illustrations on pp. 82–89 are all taken from the *Spadarfvet* album of 1906.

Illustration p. 82, top: *Sowing*
"The long shadow which had firmly attached itself to Johan's feet disturbed me; but then, perhaps it was simply my despair at ever being able to capture in my drawing the graceful movement of the sacred act of sowing." (Spadarfvet)

Illustration p. 82, bottom: *Mowing*
Larsson, who now styled himself "artist and farmer" since purchasing Spadarfvet, recorded in his album of the same name all the different kinds of work arising in the course of the farming year.

Illustration p. 83, top: *Threshing*
Larsson enlightens his reader in pictures and words as to the full extent of agricultural and other manual activities needing to be done on his autarkical farm. Here in the barn, the air thick with fragrances and dust, his farmhands are separating the ears from the stalks: threshing.

Illustration p. 83, bottom: *Winnowing*
Winnowing means "separating the wheat from the chaff". In the area around Sundborn, however, the farmers grow oats, rye and barley. The blue of the winnowing machine prompted the painter to do this watercolour.

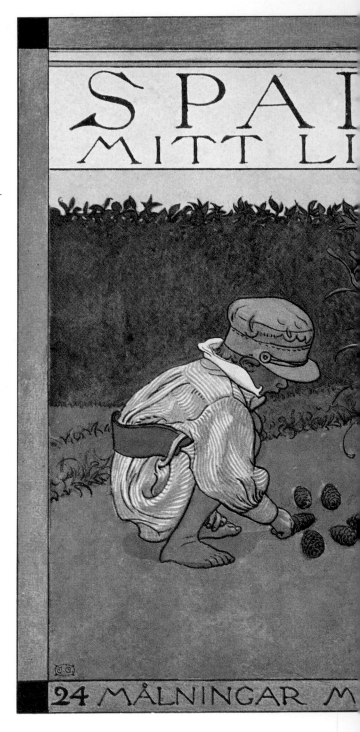

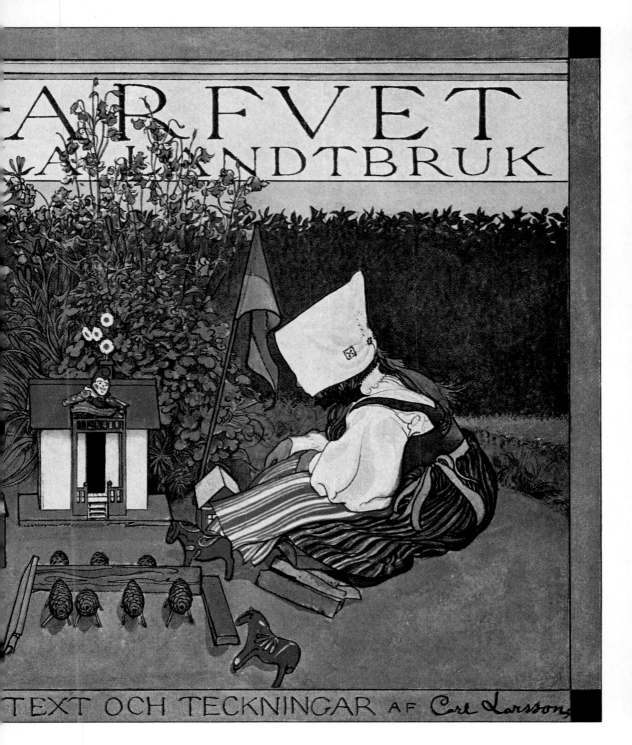

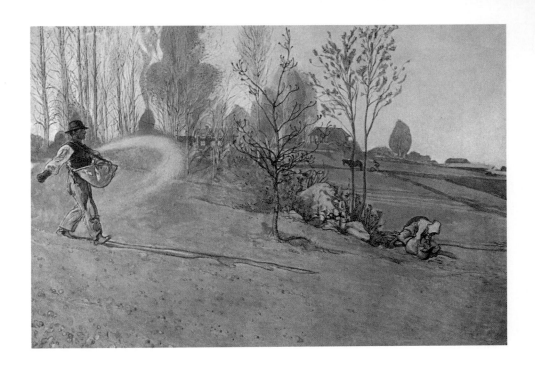

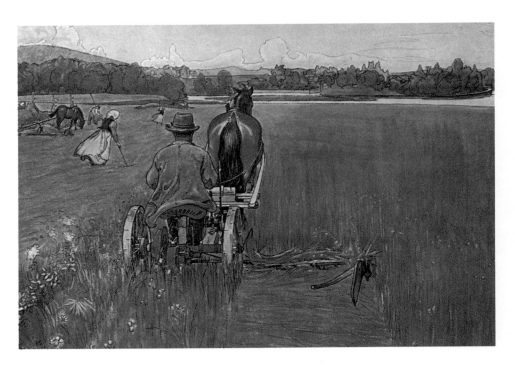

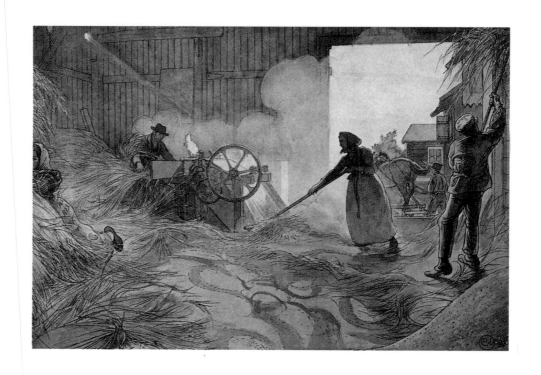

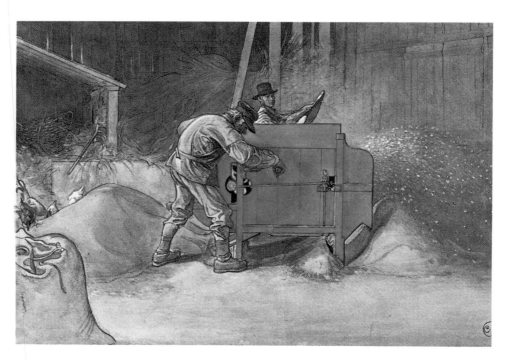

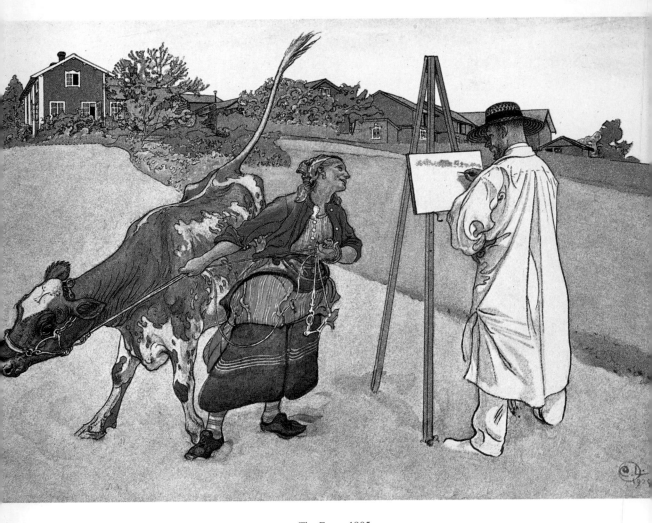

The Farm, 1905
Johanna, the faithful peasant-woman,
her cow in tow, is passing Carl Lars-
son, who has depicted himself draw-
ing his estate: "From left to right...
the farm stretches in its entirety and
practical beauty; then come the ser-
vants' quarters, the henhouse, the
stables, the toilet, the manure heap,
the barn, and finally the pigsty."
(*Spadarfvet,* p. 16)

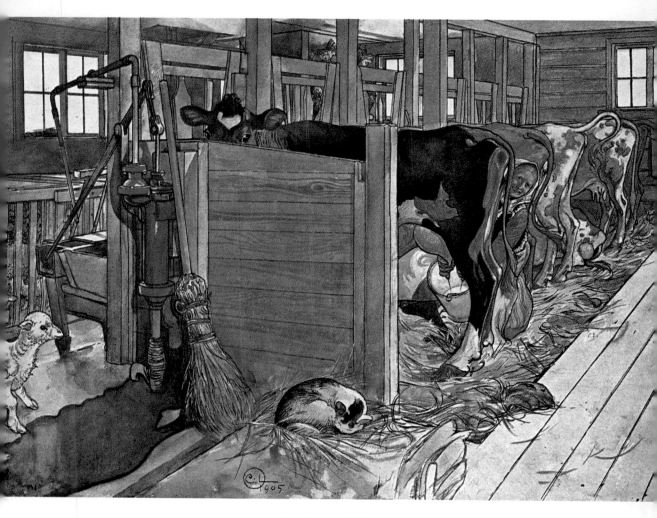

The Cowshed, 1905
Johanna "engaged in milking, in her
charming posture, the pail between
her legs and knees" (*Spadarfvet*). The
cowshed is presented in this clever di-
agonal composition as a fully func-
tioning working area for the produc-
tion of milk.

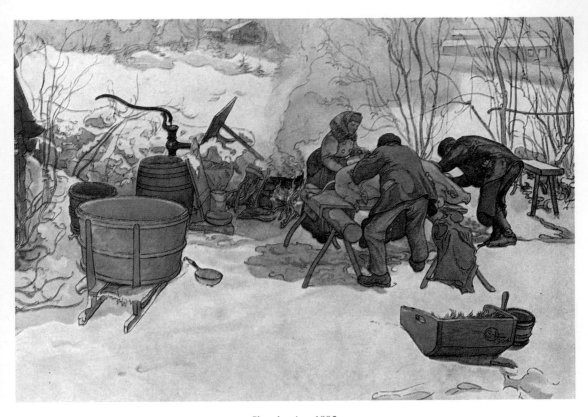

Slaughtering, 1905
The artist confronted the slaughtering
of hens, calves and pigs with just as
many scruples as he did fishing. Here
we see pig slaughtering in a winter
landscape.

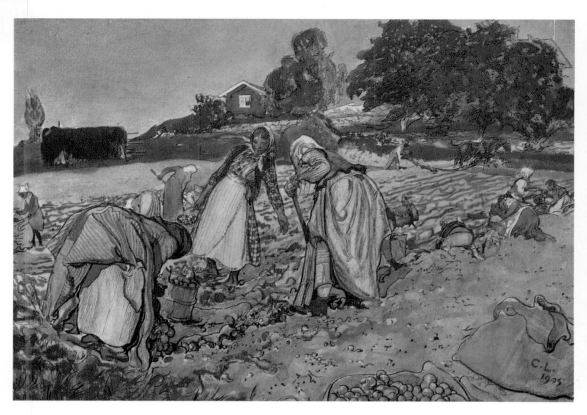

The Potato Harvest, 1905
Everyone willing to work was en-
listed, and the children were even
given special autumn holidays (called
"potato holidays"), so that the pota-
toes could be dug up from the earth in
time before the onset of the autumn
rains.

The Apple Harvest, 1904,
Stockholm, Bonnierska Porträttsam-
lingen, Nedre Manilla
The fruit harvest in 1904 yielded such
an abundance of apples that Karin,
the children and the maids had to
combine forces to gather them all in,
storing the apples on the attic of the
main house throughout the winter.

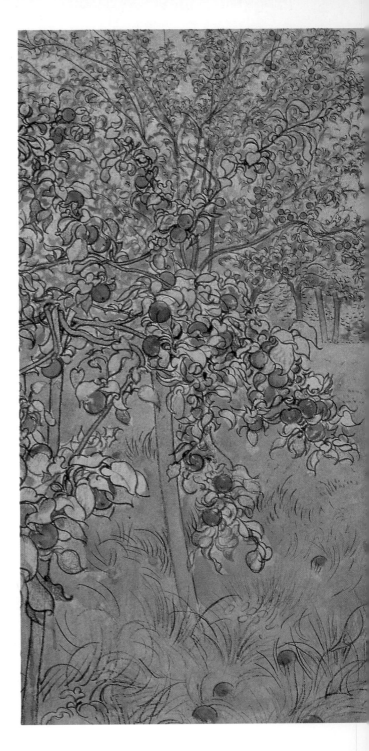

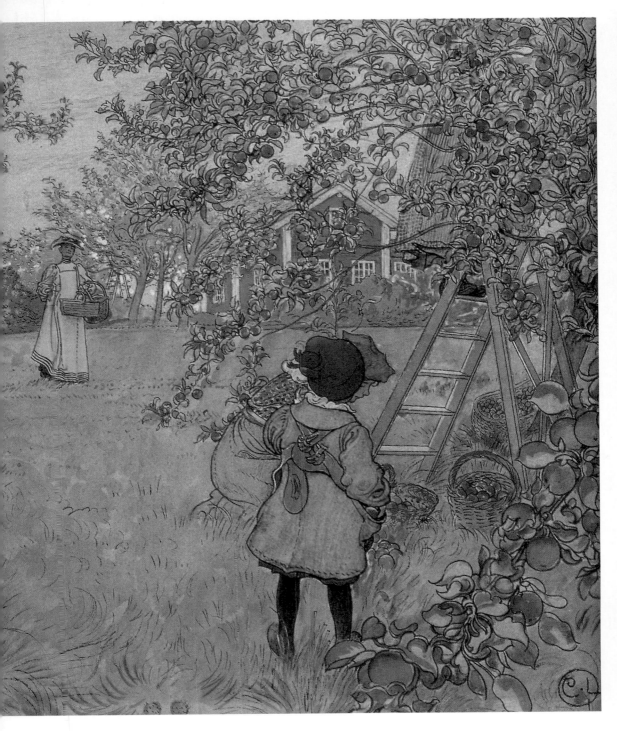

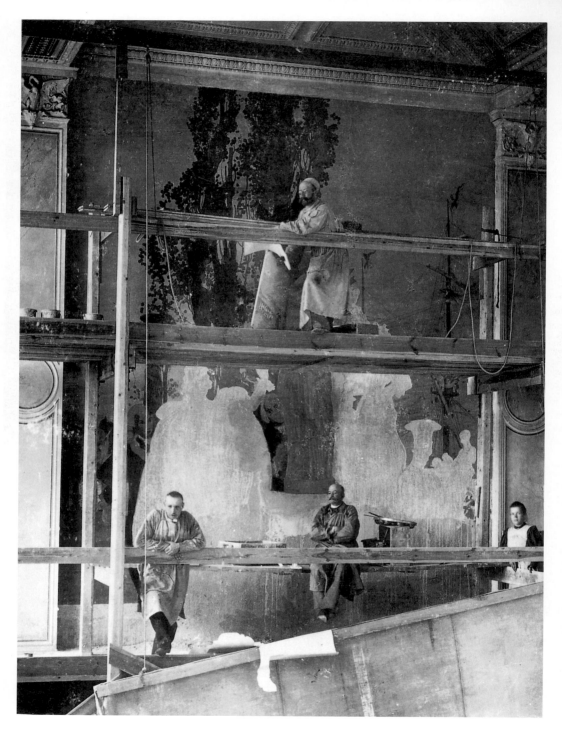

Gustav III Receiving Classical Works of Art
Larsson has portrayed examples of three artistic genres in his frescos, namely those of architecture, sculpture and painting, in the context of outstanding events from Swedish history.

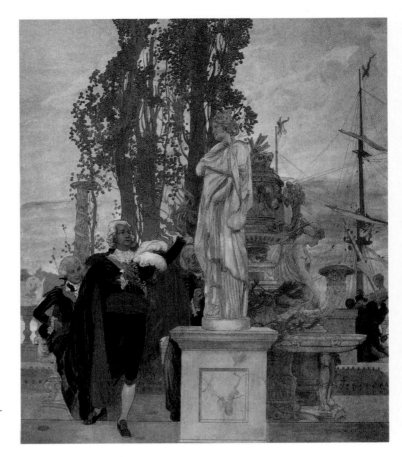

Illustration page 90:
Carl Larsson, Gustav Fjaestad and Antonio Bellio working on the frescos in the Nationalmuseum, summer 1896, photograph in Stockholm, Nationalmuseum, photo archives. Larsson began in 1888 with three designs for the six areas in all of the staircase in the Stockholm Nationalmuseum. A year later, he received the second prize, and in autumn 1896, following their reworking, they were completed.

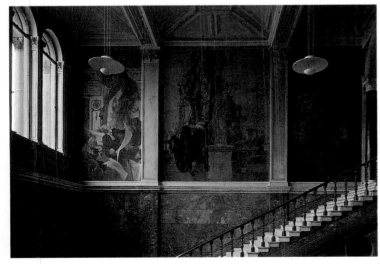

View of the north wall of the staircase in the Stockholm Nationalmuseum, the lower stairs.
Left: Lovisa Ulrika and Carl Gustav Tessin. Right: Gellman in Sergel's studio. Lively, watercolour-like frescos of lineament and hazy paint.

Carl Larsson: Chronology
1853–1919

1853 Carl Larsson is born on 28th May in Prästgatan 78, Stockholm.

1857 Birth of his only brother, Johan; the family moves to a one-room apartment in Magnigränd No. 7, later No. 5. He attends the Poor School, and later the Ladugardsland elementary school.

1866 Cholera in Stockholm. Carl Larsson is accepted for the foundation course of the Art Academy.

1866–1876 Attends the Academy in Stockholm.

1869 Accepted for the Academy's course on classical art after winning 12 medals in the foundation class. Editorial work with *Pajas*, a students' newspaper.

1871 In addition to his studies at the Academy, he is working in the photographic studio of the Roesler brothers, and as a graphic artist for *Kasper*, a humorous paper.

1873 Reward for drawing models. Advances to the Academy's painting class.

1875 First illustrations for literary works: fairy tales, novels, plays. A year later, first portraits. Employed until 1889 as a graphic artist for *Ny Illustrerad Tidning (New Illustrated Newspaper)*.

1877 First journey to Paris; two summers spent in Barbizon, the winter between in Stockholm. Applies unsuccessfully for a travel scholarship. Living in great poverty; contemplates committing suicide.

1879 Makes the acquaintance of Karin Bergöö, his future wife, and August Strindberg. Commissioned to paint the ceiling and lunettes in the Bolinder Palace on Blasieholmshamnen. His fortunes begin to improve, and a period of travel begins, taking in Sweden, Paris, Italy, and London.

1881 Illustrations for Strindberg's *The Swedish People on Workdays and Public Holidays*.

1882 Settles in Grez, near Paris, spending his summers there until 1887. Paints his first plein-air pictures; reveals a preference for working in watercolours.

1883 Watercolours from Grez are awarded a medal by the Paris Salon; others are purchased by the Stockholm National Museum. Patronage over many years to come from Pontus Fürstenberg, the Gothenburg art collector.

1884 Watercolours and illustrations for Anna Maria Lenngren's poetic works. Birth of Suzanne, his and Karin's first daughter. Six further children follow, until 1900.

1886 Committee member of the Swedish artistic group "Opponents".

1888 Works on the Fürstenberg triptych and his designs for the staircase frescos in the Stockholm National Museum. The family inherits the little house "Lilla Hyttnäs" in Sundborn near Falun, in the province of Dalarna.

1889 Second Prize for three designs for the frescos in the National Museum. Awarded a 1st Class medal at the World Exhibition in Paris. From now on, he spends his summers in Sundborn.

1890 Begins the *Our Home* (*Ett Hem*) watercolour series. Wall paintings until 1891 for the Gothenburg Girls' School.

1891 First Prize for his revised design for the Stockholm National Museum frescos. Illustrations for Schiller's *Cabal and Love*.

1892/94 Travels to Italy to study Renaissance monumental painting.

1894 Illustrations for Viktor Rydberg's *Singoalla*. Larsson's designs for the Stockholm frescos are accepted.

1896 Completion of the National Museum frescos. Etching course; graphic works.

1897 Purchases the farms of Spadarfvet and Kartbacken in order to be able to extend Lilla Hyttnäs. He now styles himself "artist and farmer". *They're Mine* (*De mina*) and 20 watercolours from the *Our Home* series are exhibited in Stockholm.

1898 Commences work on the cartons for the Stockholm Norra Latin

School; they are completed in 1901. Completion of the ceiling paintings and lunettes for the Stockholm Opera.

1899 *Our Home* appears in book form.

1900 1st Class medal at the World Exhibition in Paris.

1901 The Larsson family finally moves to Sundborn. Publication of Georg Nordensvan's first book about Carl Larsson.

1902 Publication of the *Larssons* book.

1904 New sketches on "Gustav Wasa's Entry" for the Stockholm National Museum. Begins the *Spadarfvet* album.

1905 His son Ulf dies. Commission to execute the ceiling painting in Stockholm's new Dramatic Theatre; "The Creation of Drama" is completed in 1907.

1906 *Spadarfvet* appears in book form, and simultaneously in a German edition, entitled "Bei uns auf dem Lande". Portrait commissions.

1907 Larsson's book *The Swedish Woman in the Course of the Ages* (*Svenska kvinnan genom seklen*) is published.

1908 Strindberg publicly attacks Larsson – the end of their friendship.

1910 *On the sunny side* (*Åt solsidan*) is published.

1911 Larsson attempts until 1916 – unsuccessfully – to round off the decoration of the National Museum with several different designs for *Winter Solstice Sacrifice*. An exhibition and a prize in Rome: the Uffizi in Florence purchase *Self-examination* from 1906. Larsson attacks Modernism.

1913 The *Other People's Children* album (*Andras barn*) is published.

1916 Exhibition in Copenhagen. Portrait of K. O. Bonnier.

1919 Completion of his memoirs, entitled *Me (Jag)*. Carl Larsson dies on 22nd January in Sundborn.

Illustration acknowledgements:
In addition to those persons and institutions cited in the legends to
the pictures, the following should also be mentioned:
The Publisher's archives: pp. 1, 2, 5, 6, 7, 8, 9, 12, 13, 16, 17 bot-
tom, 18, 19, 23 right, 25, 28, 29, 30, 31, 32, 33, 34, 37, 38, 39, 44,
45, 46 left, 56, 57, 58, 59, 62, 64, 68, 69, 70, 71, 72, 73, 74, 76 left,
78, 79, 81, 82–87, 88 left
© Christie's, London: pp. 24, 35